DOVER DIGITAL DESIGN SOURCE

NEO-CLASSICAL DESIGN AND ORNAMENT

EDITED BY

CAROL BELANGER GRAFTON

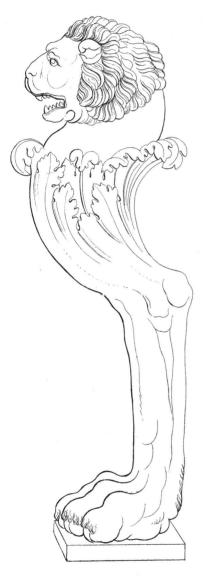

DOVER PUBLICATIONS, INC. MINEOLA, NEW YORK

At Dover Publications we're committed to producing books in an earth-friendly manner and to helping our customers make greener choices.

Manufacturing books in the United States ensures compliance with strict environmental laws and eliminates the need for international freight shipping, a major contributor to global air pollution. And printing on recycled paper helps minimize our consumption of trees, water and fossil fuels.

The text of this book was printed on paper made with 10% post-consumer waste and the cover was printed on paper made with 10% post-consumer waste. At Dover, we use Environmental Defense's

Paper Calculator to measure the benefits of these choices, including: the number of trees saved, gallons of water conserved, as well as air emissions and solid waste eliminated.

Please visit the product page for *Dover Digital Design Source #8: Neo-Classical Design and Ornament* at www.doverpublications.com to see a detailed account of the environmental savings we've achieved over the life of this book.

The CD-ROM in this book contains all of the images. Each image has been saved as a 300-dpi high-resolution JPEG and a 72-dpi Internet-ready JPEG. There is no installation necessary. Just insert the CD into your computer and call the images into your favorite software (refer to the documentation with your software for further instructions).

Within the "Images" folder on the CD you will find two additional folders—"High Resolution JPG" and "JPG." Every image has a unique file name in the following format: xxx.JPG. The first 3 characters of the file name correspond to the number printed with the image in the book. The last 3 letters of the file name, JPG, refer to the file format. So, 001. JPG would be the first file in the folder.

Also included on the CD-ROM is Dover Design Manager, a simple graphics editing program for Windows that will allow you to view, print, crop, and rotate the images.

For technical support, contact: Telephone: 1 (617) 249-0245

Fax: 1 (617) 249-0245

Email: dover@artimaging.com

Internet: http://www.dovertechsupport.com

The fastest way to receive technical support is via email or the Internet.

Copyright

Copyright © 2010 by Dover Publications, Inc. Electronic images copyright © 2010 by Dover Publications, Inc. All rights reserved.

Bibliographical Note

Dover Digital Design Source #8: Neo-Classical Design and Ornament, first published by Dover Publications, Inc., in 2010, is a new selection of images from the following books: Le Guide de L'Ornemantiste ou de L'Ornement, Charles Normand (1826); Costume of the Ancients, William Miller (1812); Selection of Ornaments in Forty Pages for the Use of Sculptors, Painters, Carvers, Modellers, Chasers, Embossers & c., R. Ackermann (1817–1819); Recueil des dessins d'ornements d'architecture, Joseph Beunat (c. 1813); Modern Style of Cabinet Work Exemplified, Thomas King (1829).

Dover Electronic Clip Art®

These images belong to the Dover Electronic Clip Art Series. You may use them for graphics and crafts applications, free and without special permission, provided that you include no more than ten in the same publication or project. For permission for additional use, please write to Permissions Department, Dover Publications, Inc., 31 East 2nd Street, Mineola, New York 11501, or email us at rights@doverpublications.com

However, republication or reproduction of any illustration by any other graphic service, whether it be in a book, electronic, or in any other design resource, is strictly prohibited.

International Standard Book Number ISBN-13: 978-0-486-99095-8 ISBN-10: 0-486-99095-8

Manufactured in the United States by Courier Corporation 99095801 www.doverpublications.com

Note

Add a Neo-Classical accent to arts and crafts projects, websites, advertisements, and more with this collection of over 800 engravings reproduced from rare, nineteenth-century sources. As a reaction to the elaborate Rococo style, Neo-Classicism focused on the revival of classical forms—mainly Ancient Greece and Ancient Rome. The peak of the Neo-Classical period was from the late-eighteenth to late-nineteenth centuries.

Exquisitely detailed, these elements played an important role in catalogs and pattern books for architects, painters, and sculptors. Among the magnificent illustrations are tables, urns, friezes, chairs, moldings, panels, vases, mythological statues, sculpted columns, elaborate entrances, and a variety of architectural designs.

	¥				

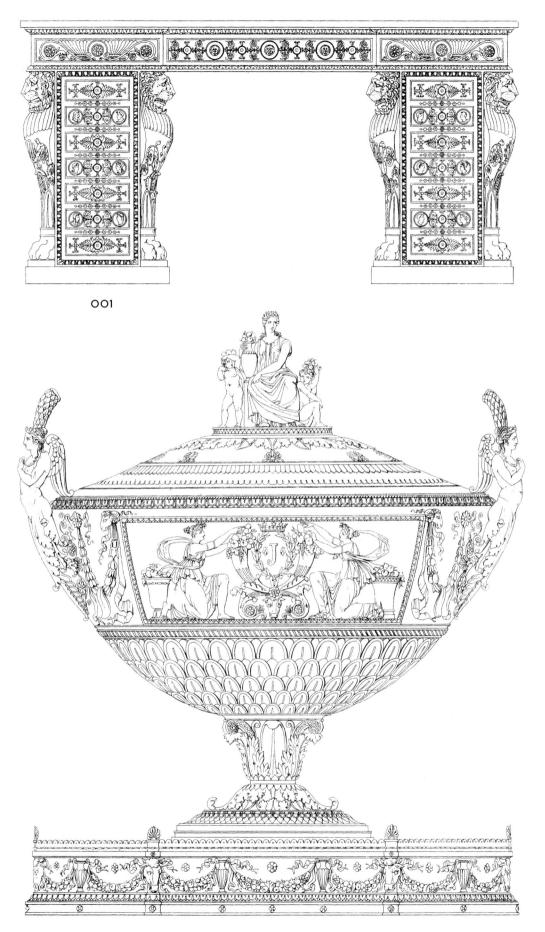

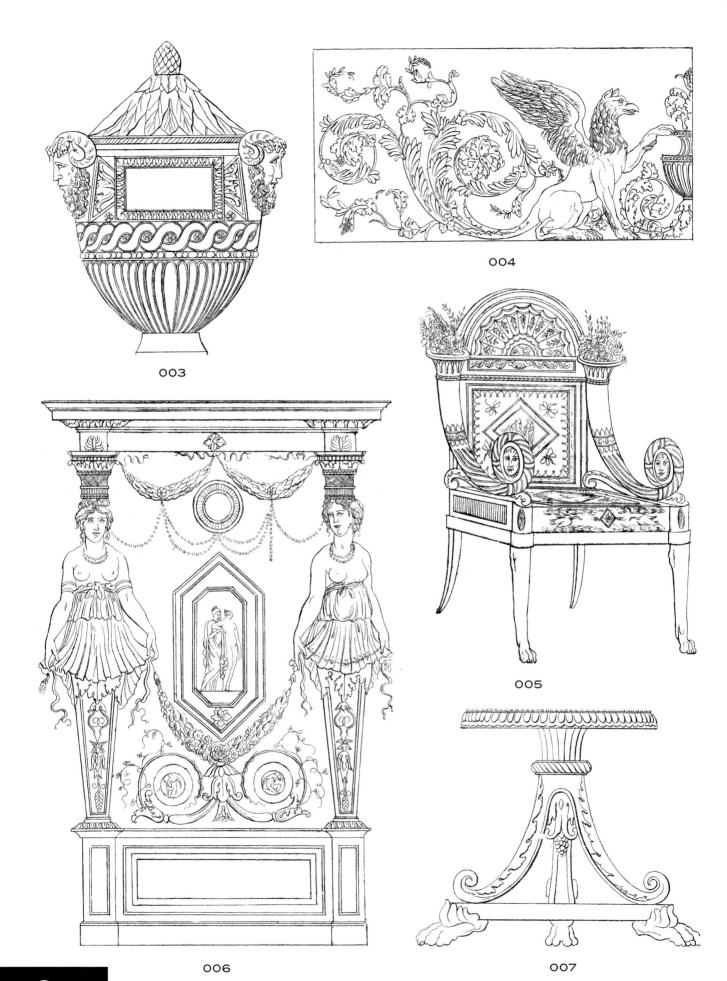

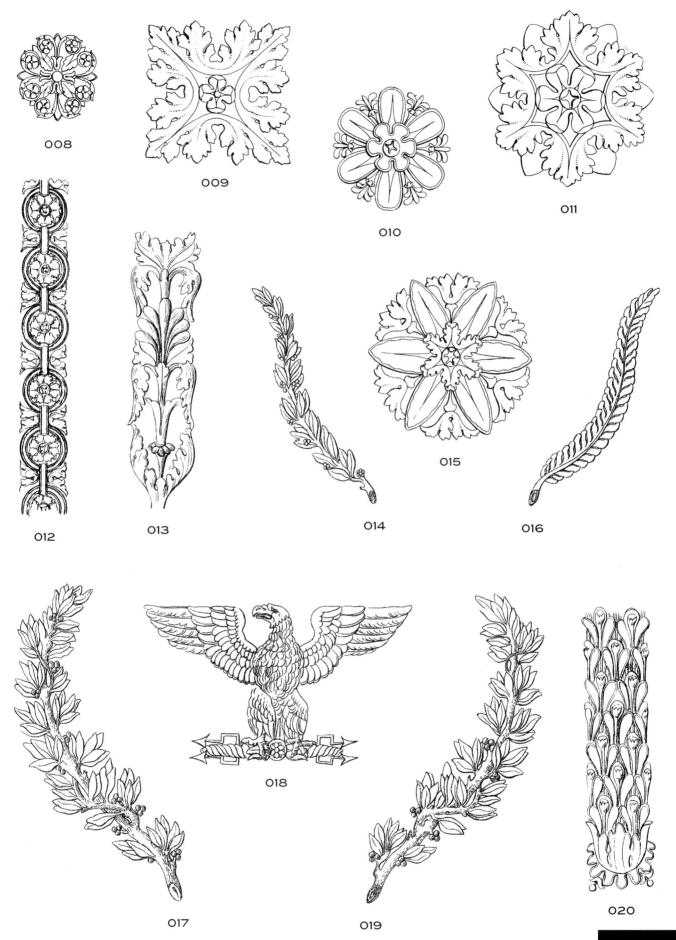

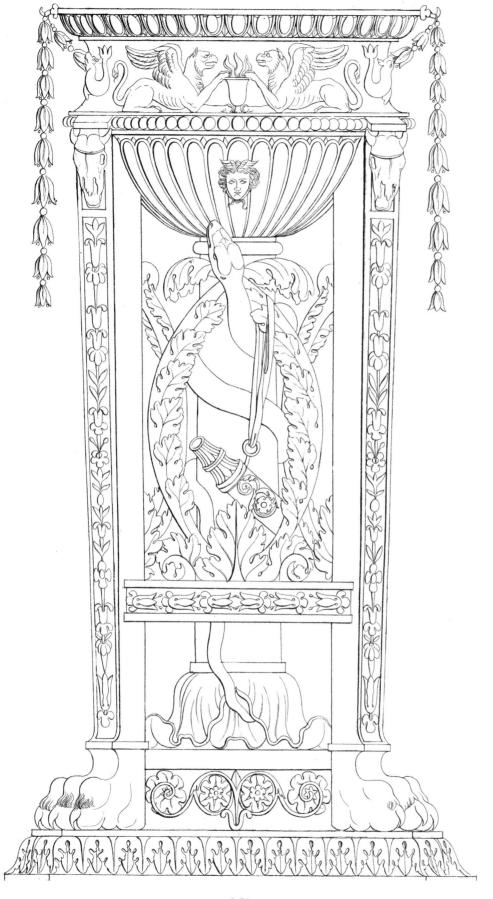

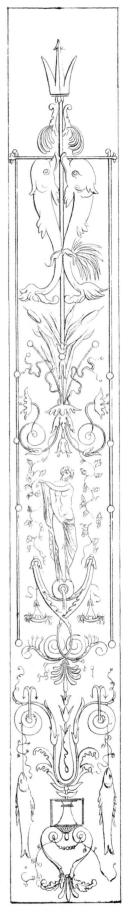

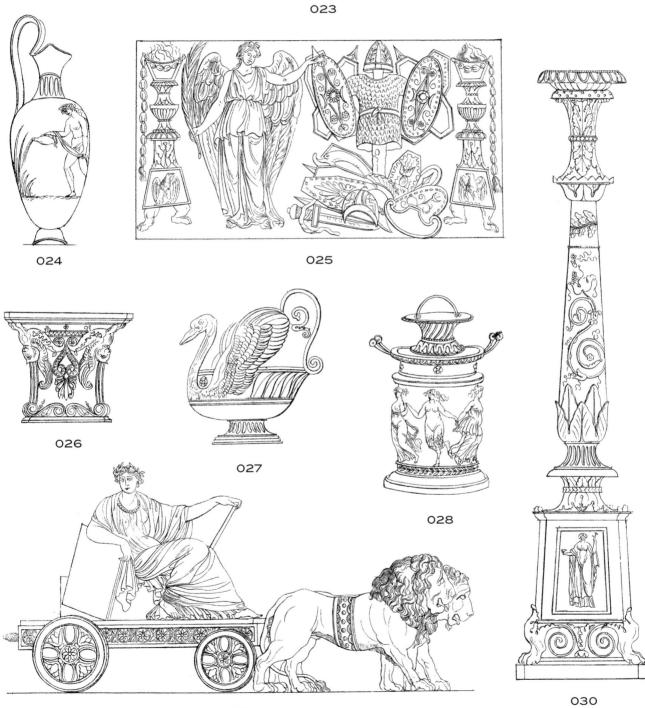

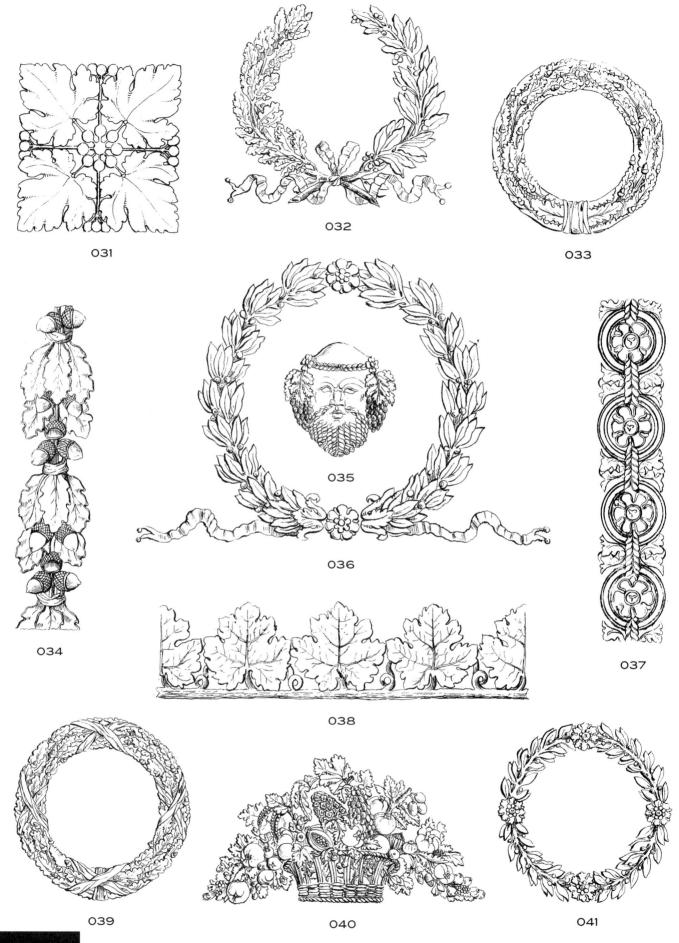

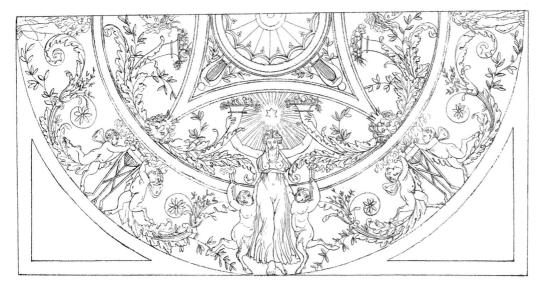

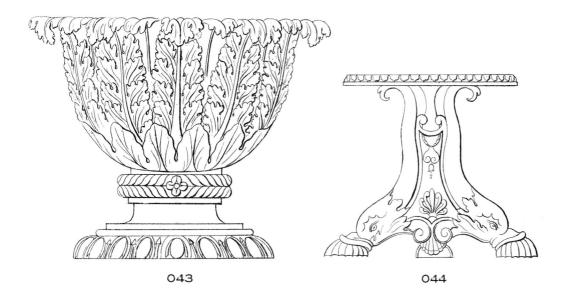

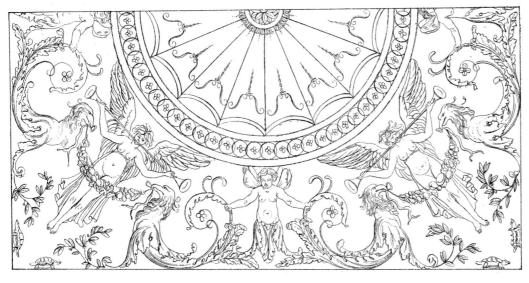

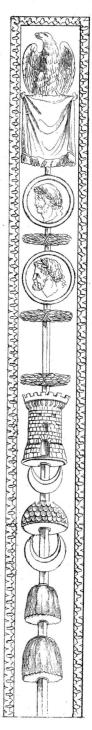

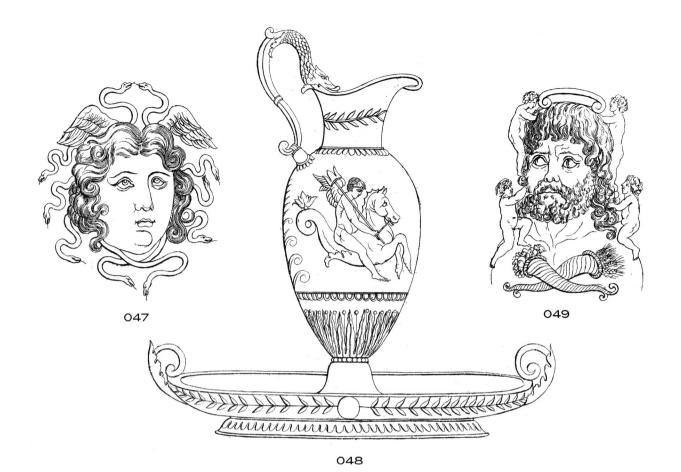

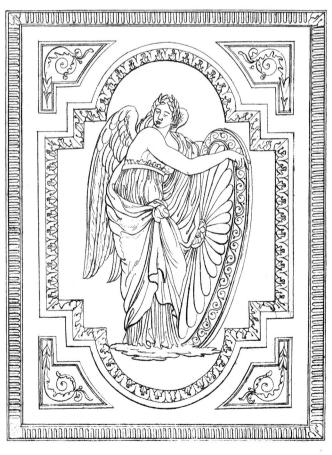

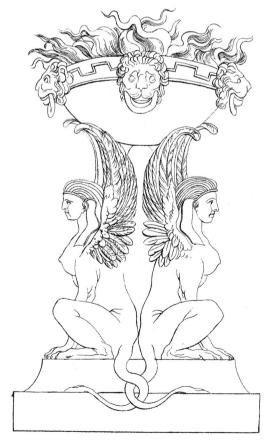

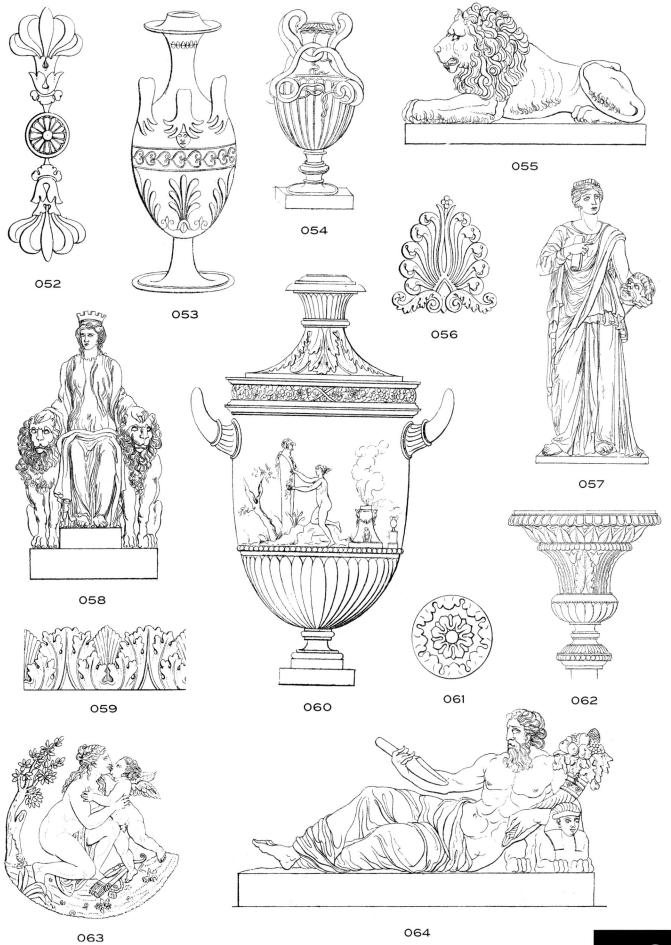

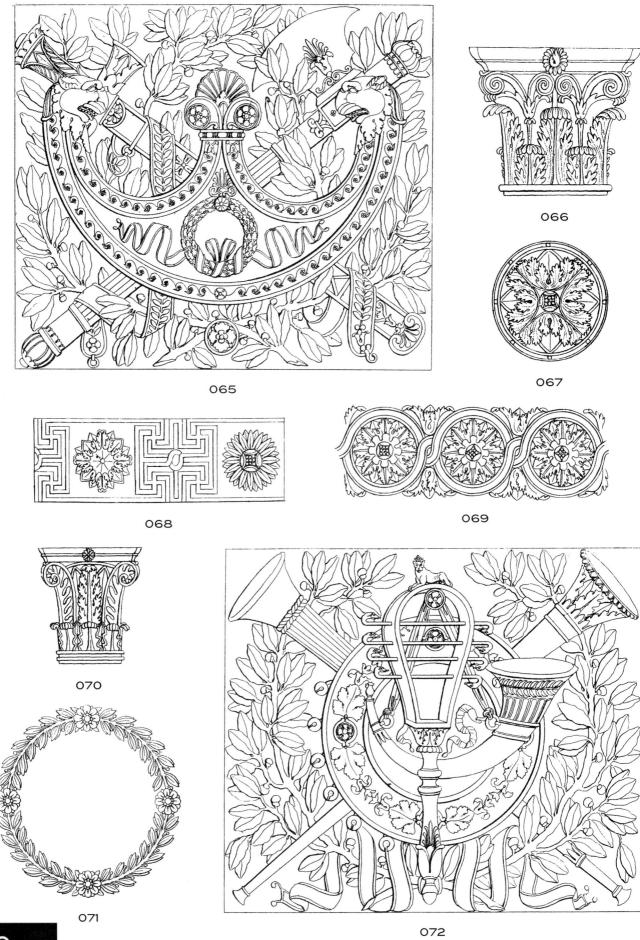

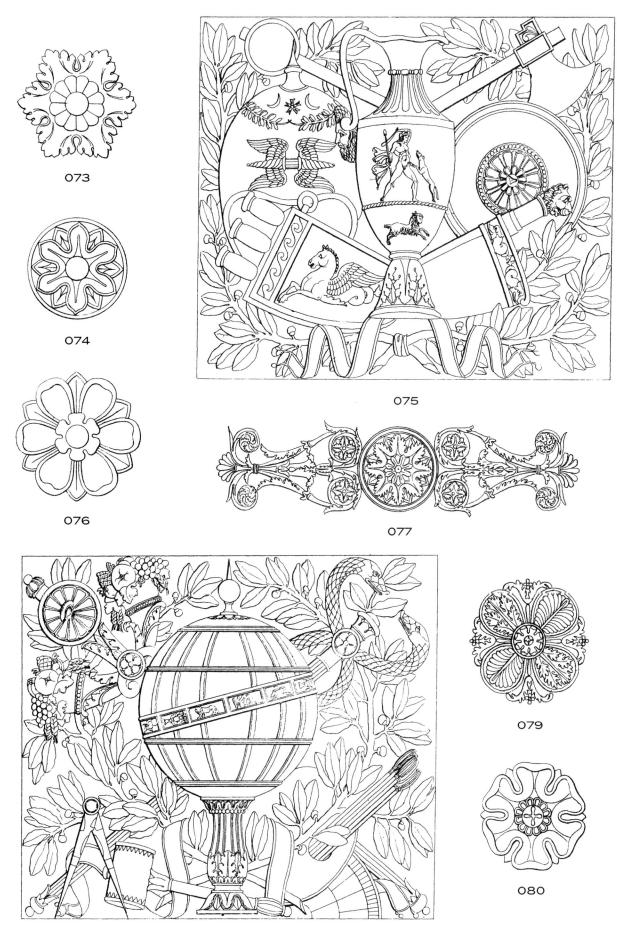

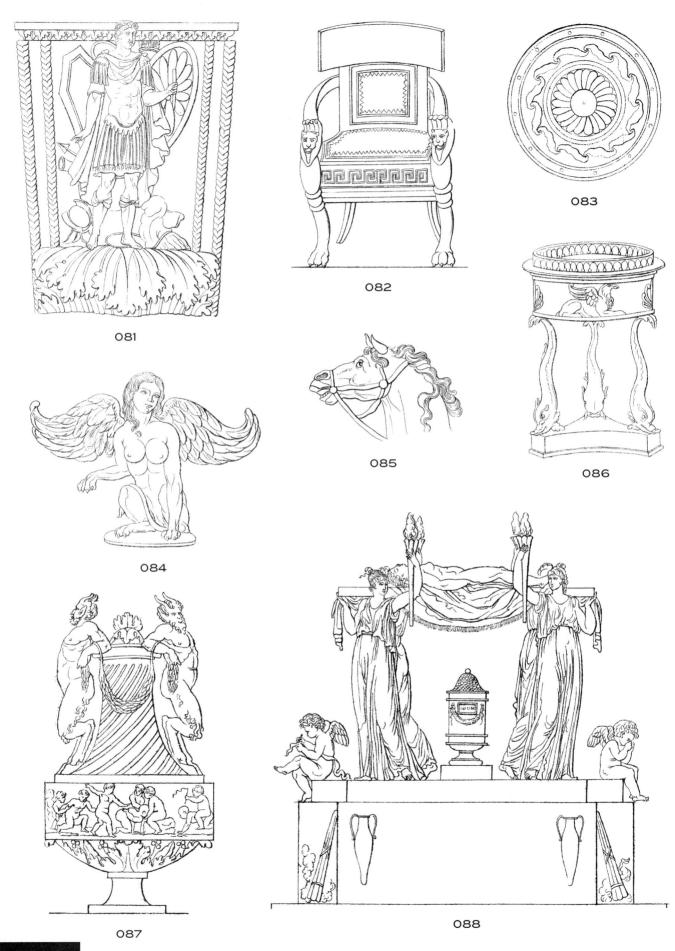

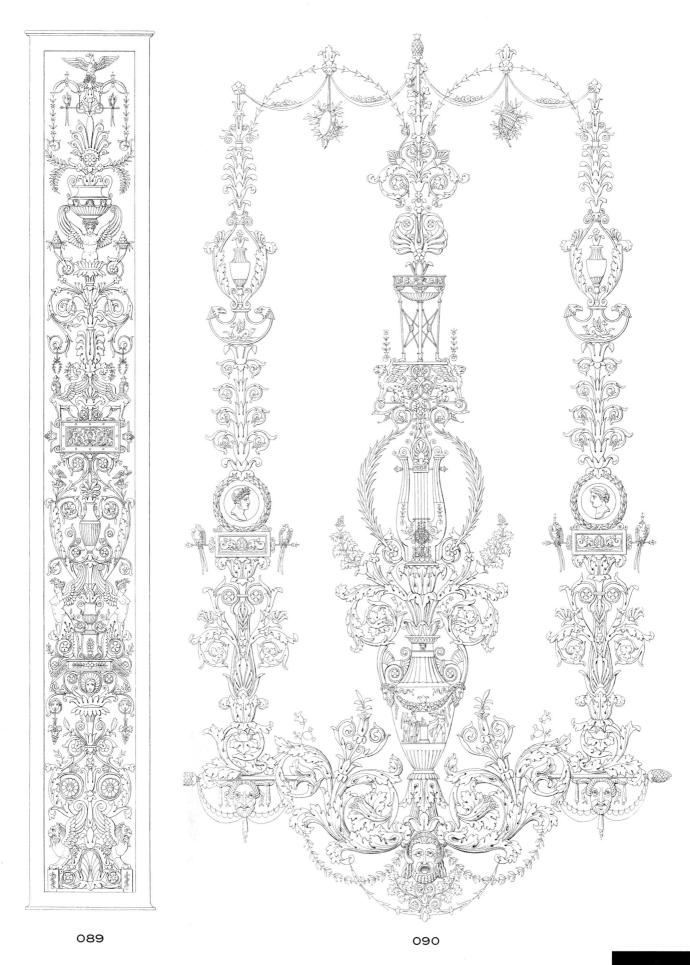

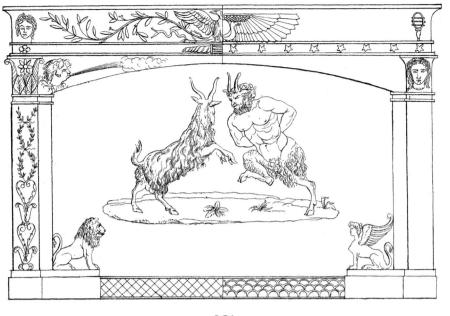

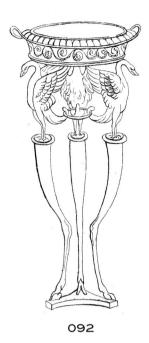

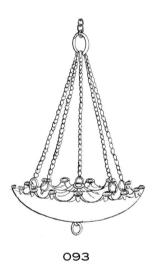

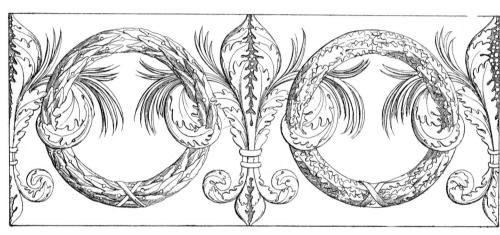

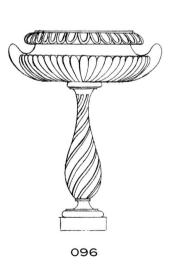

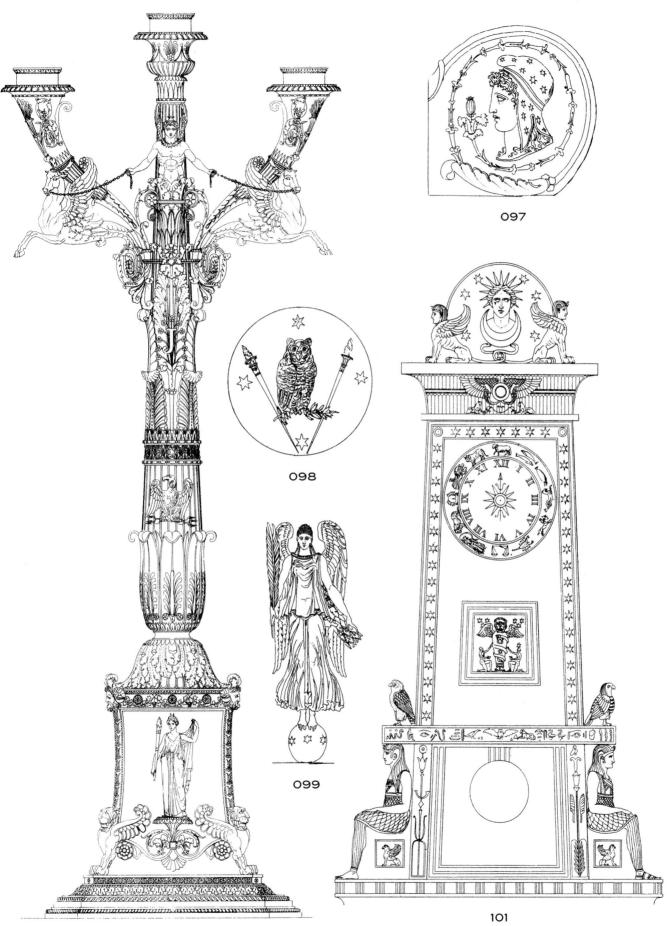

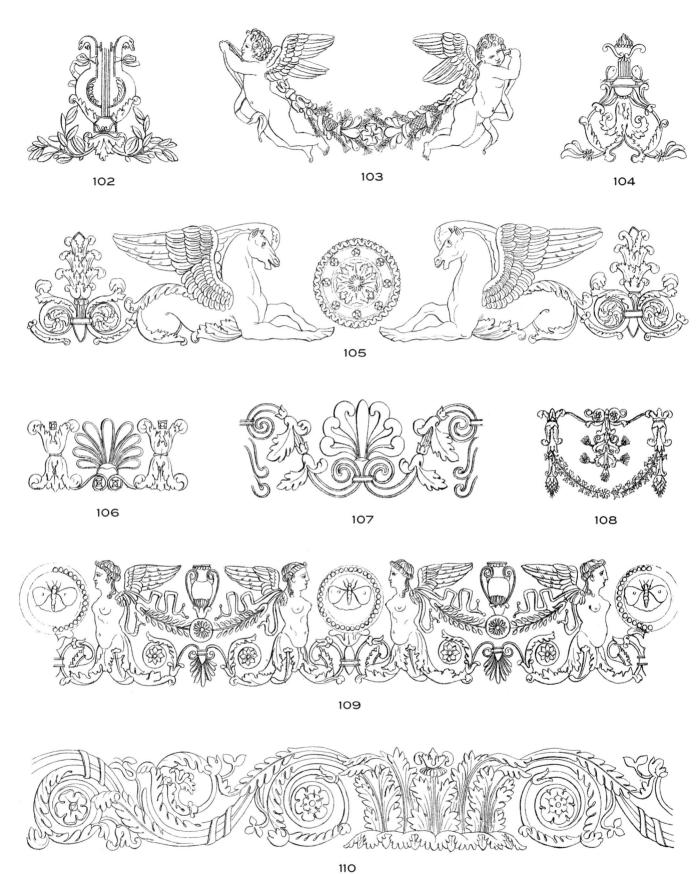

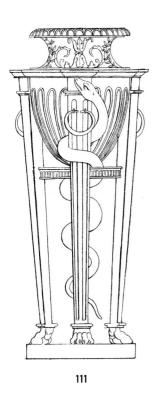

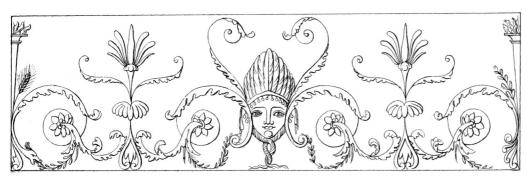

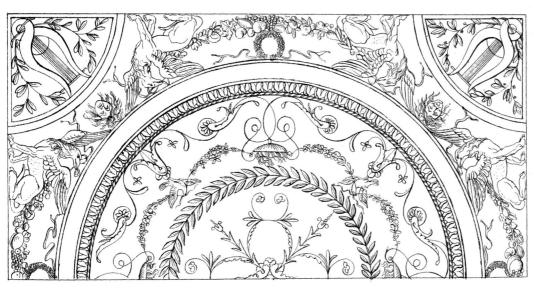

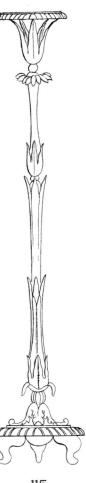

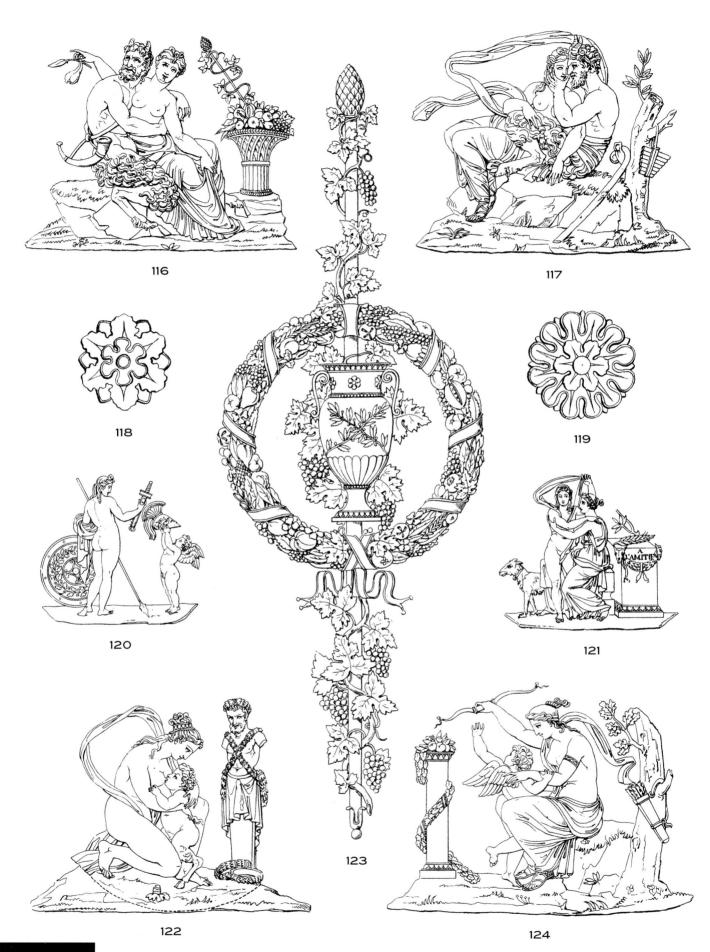

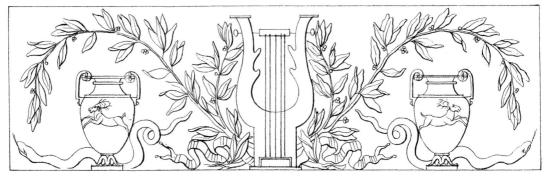

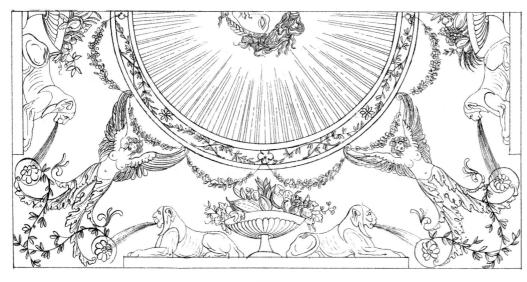

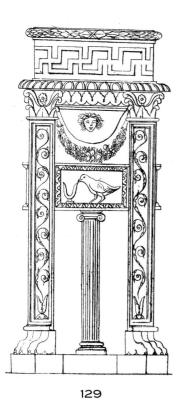

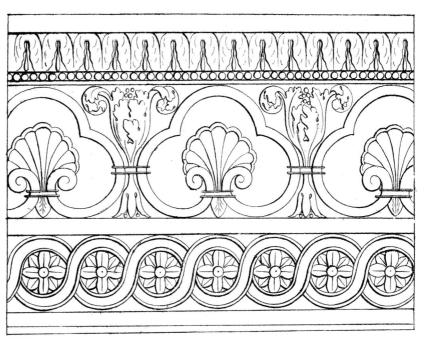

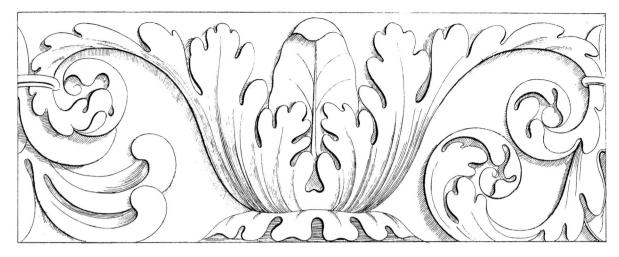

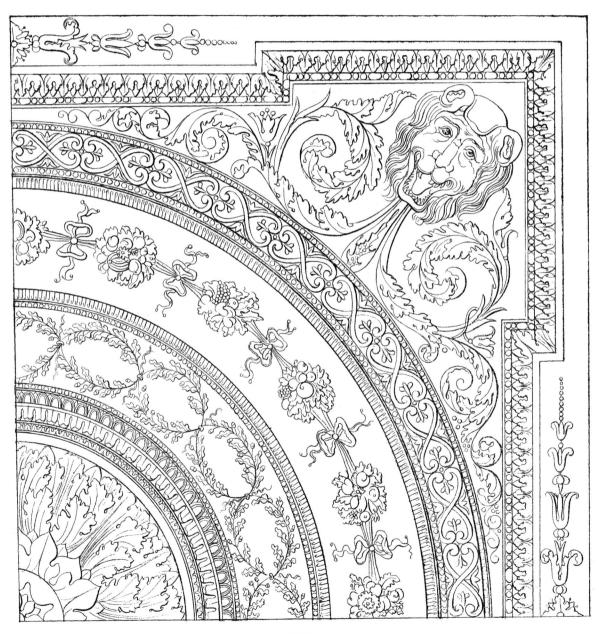

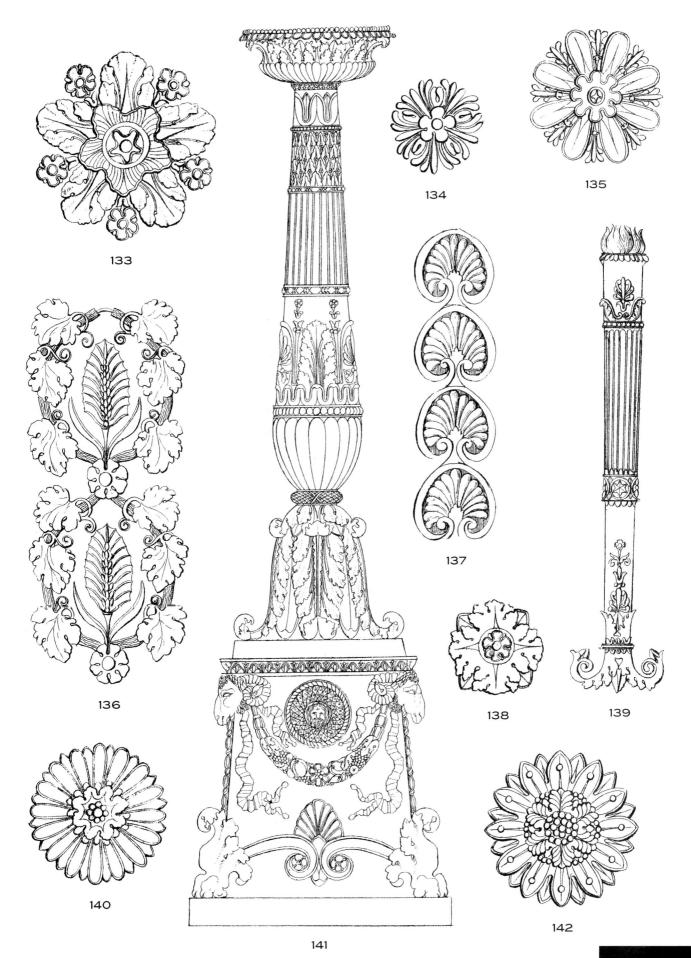

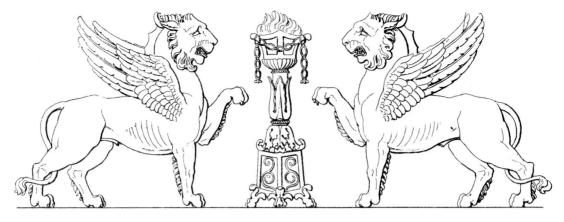

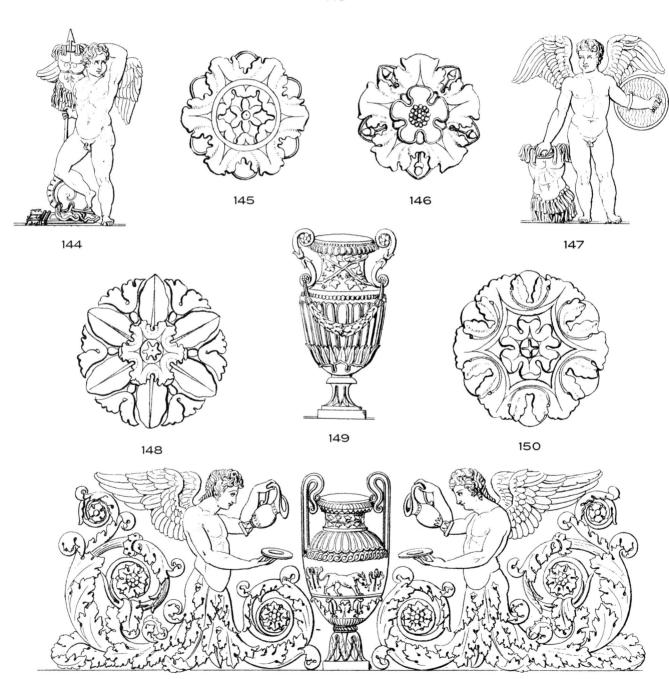

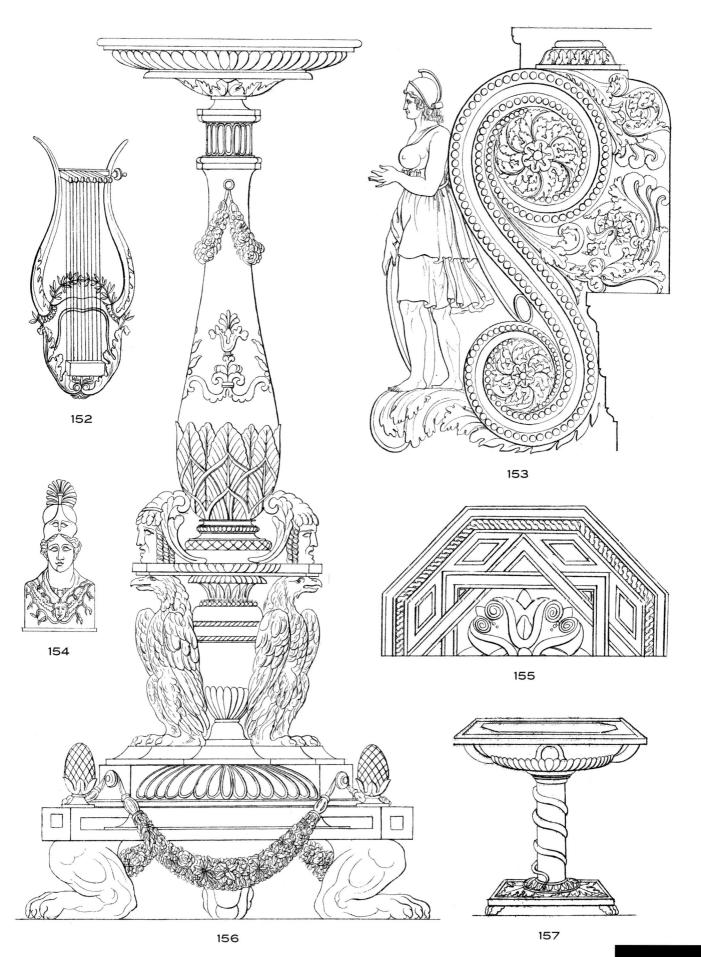

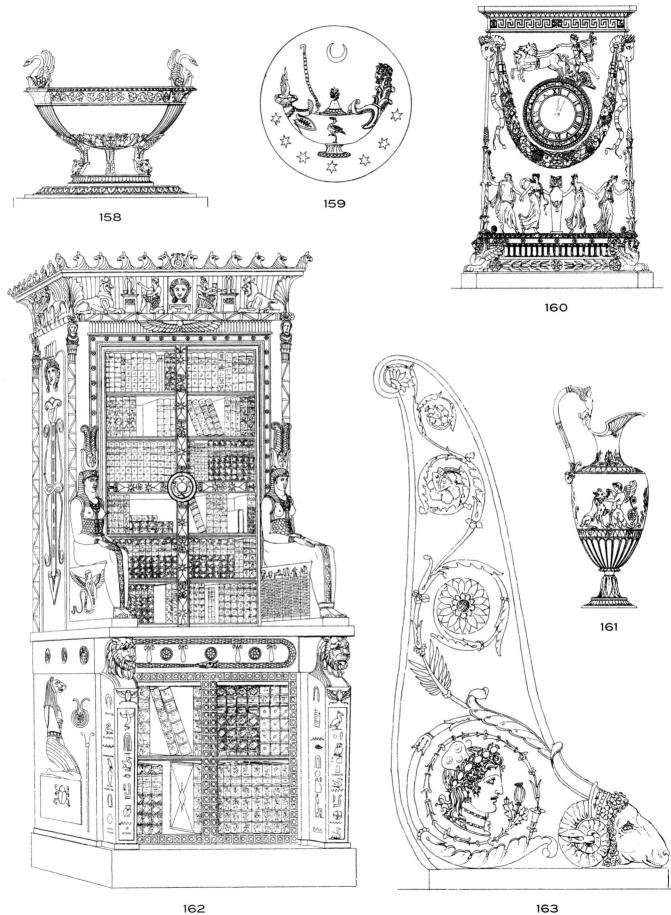

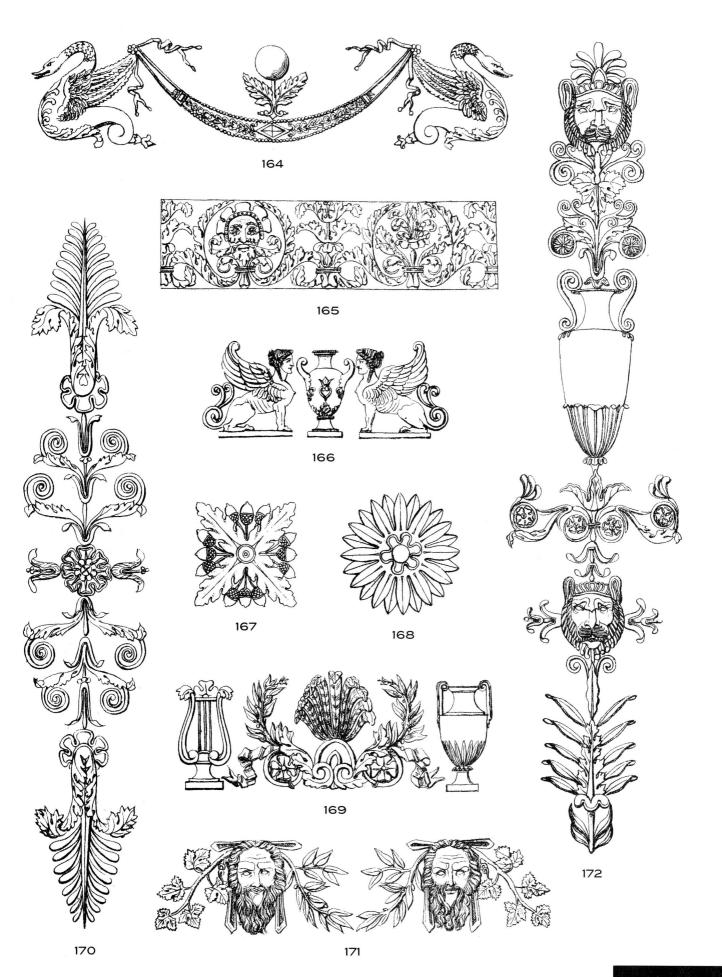

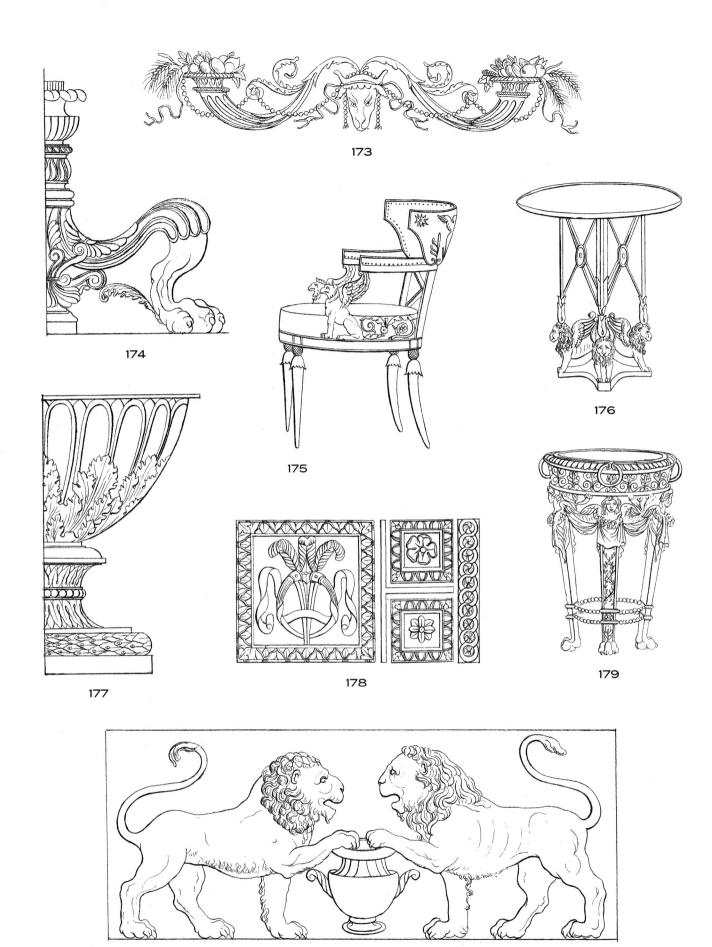

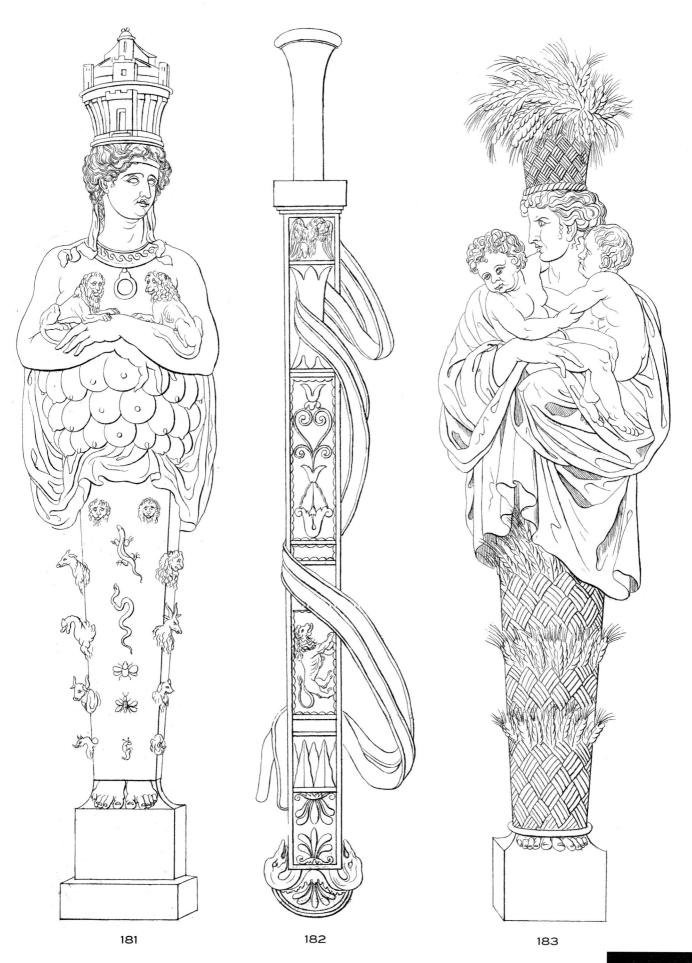

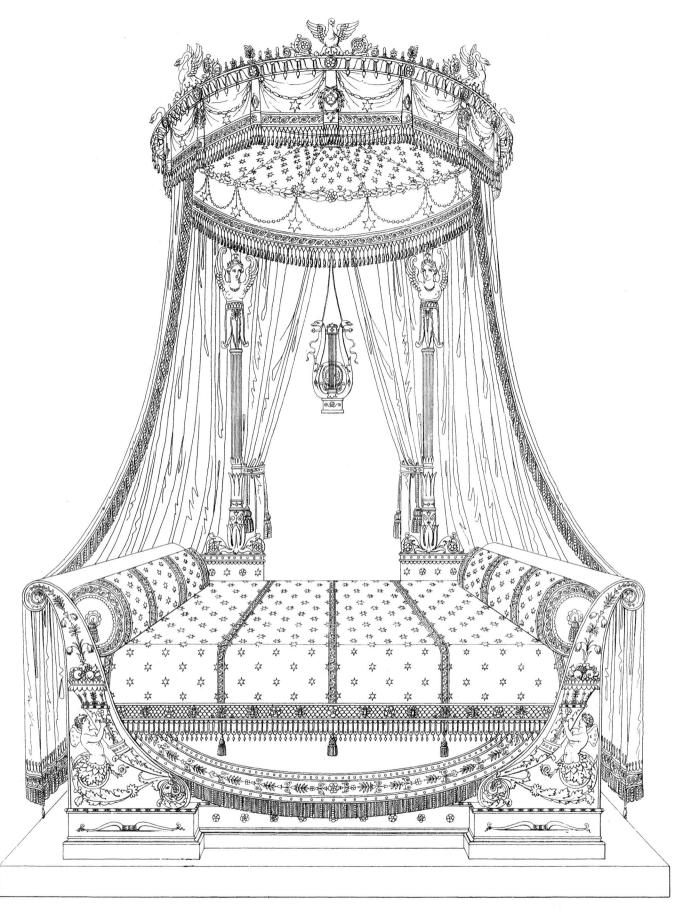

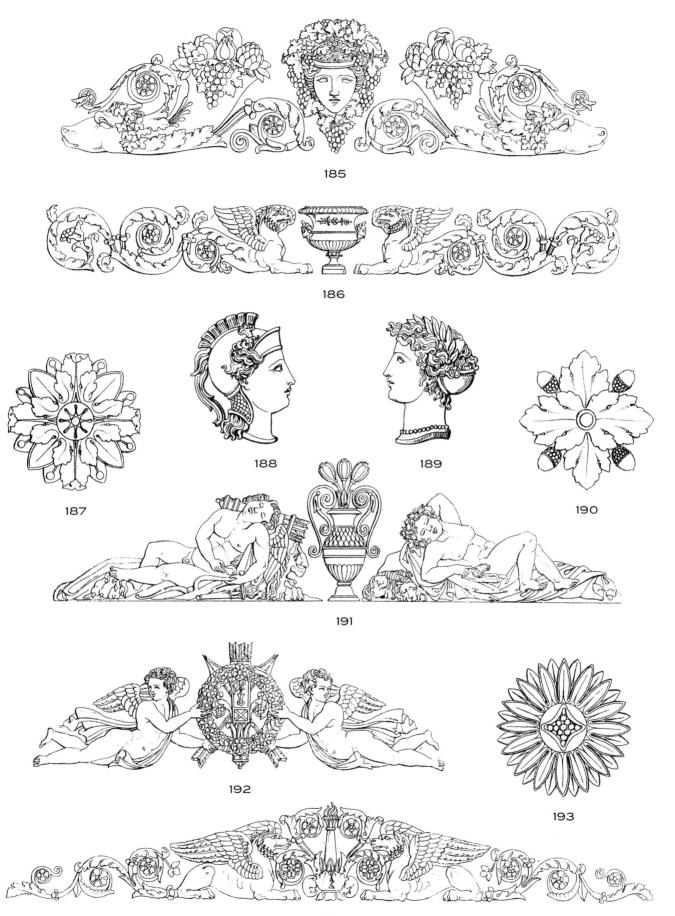

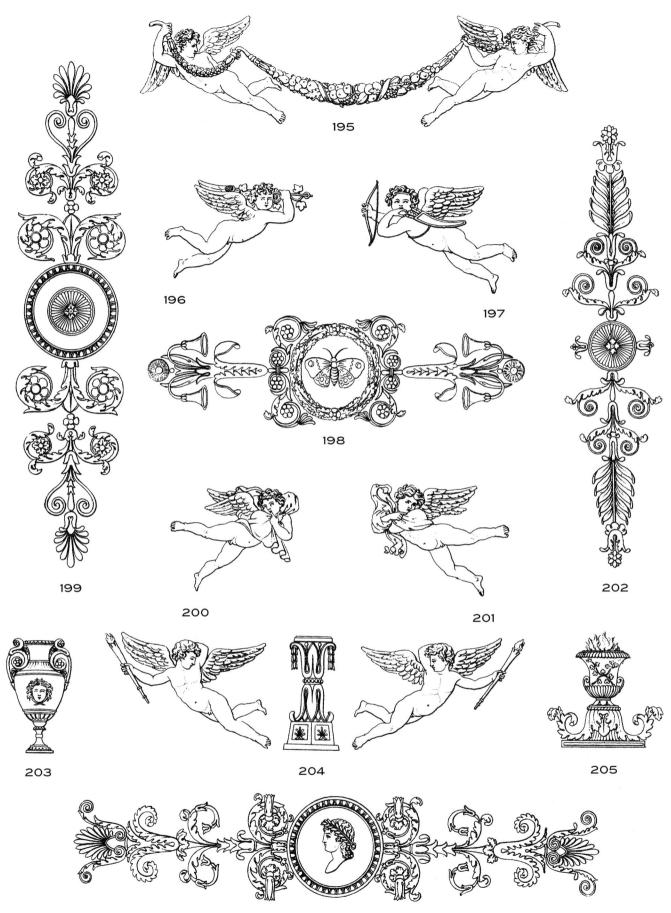

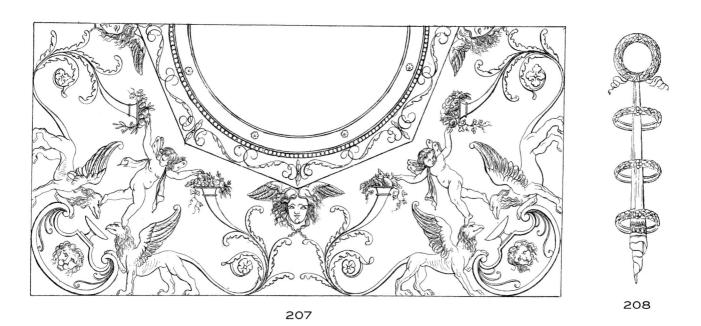

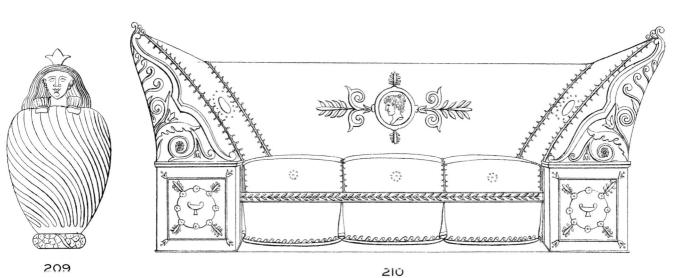

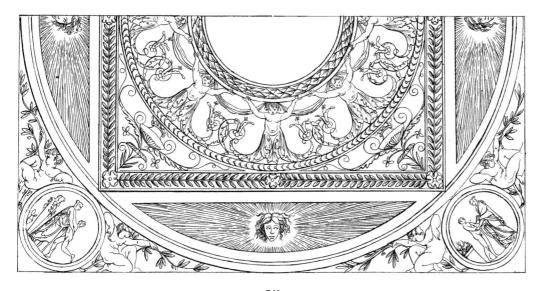

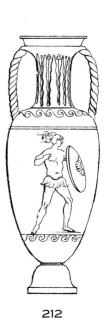

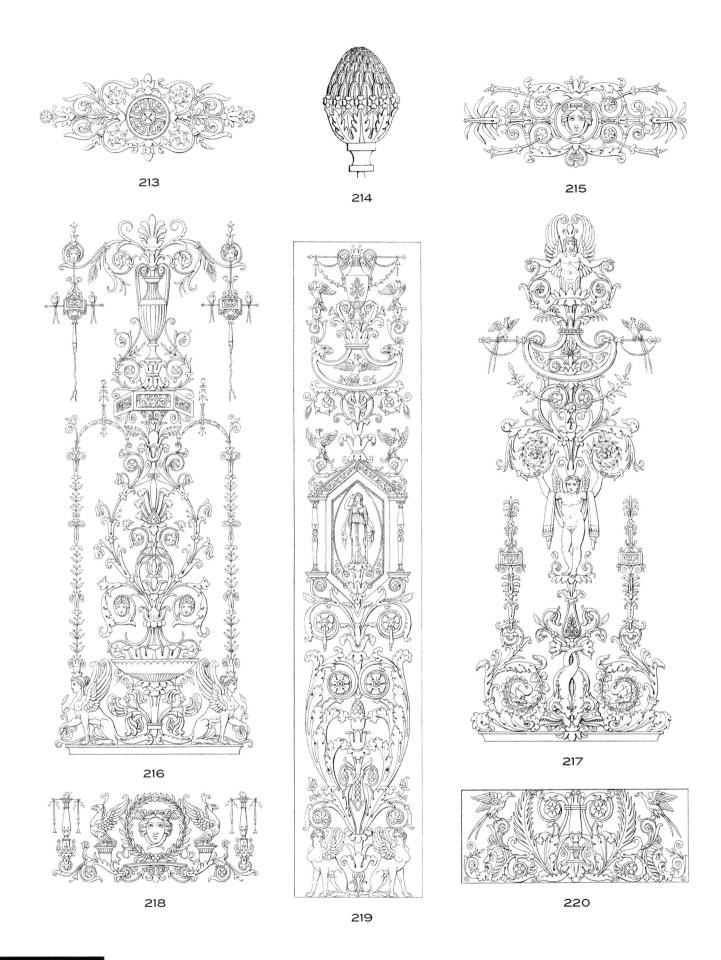

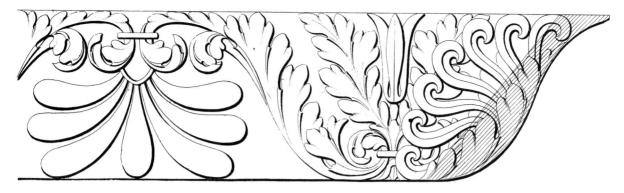

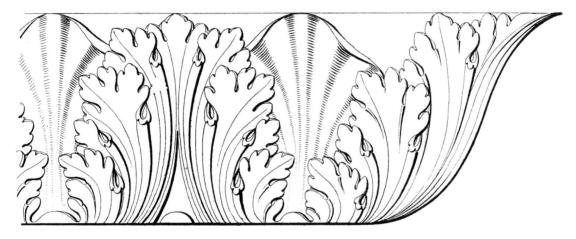

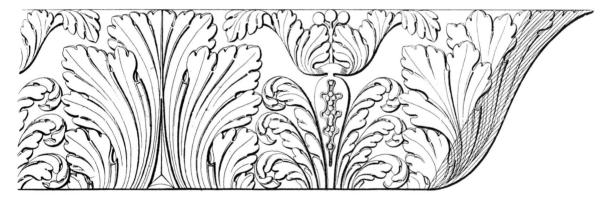

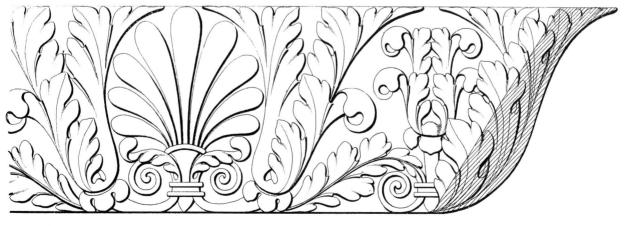

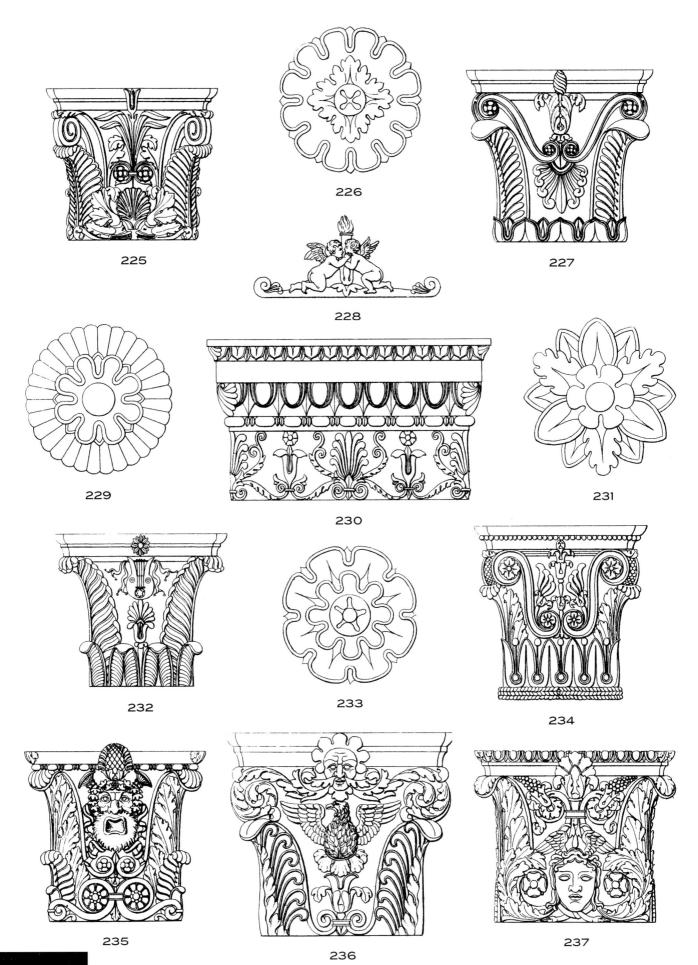

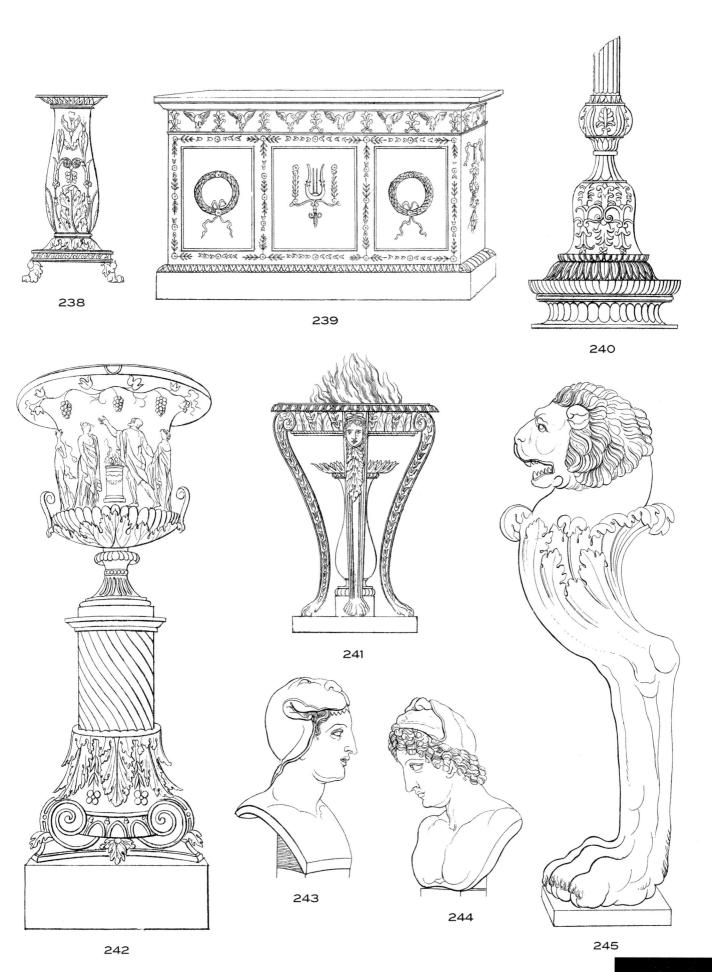

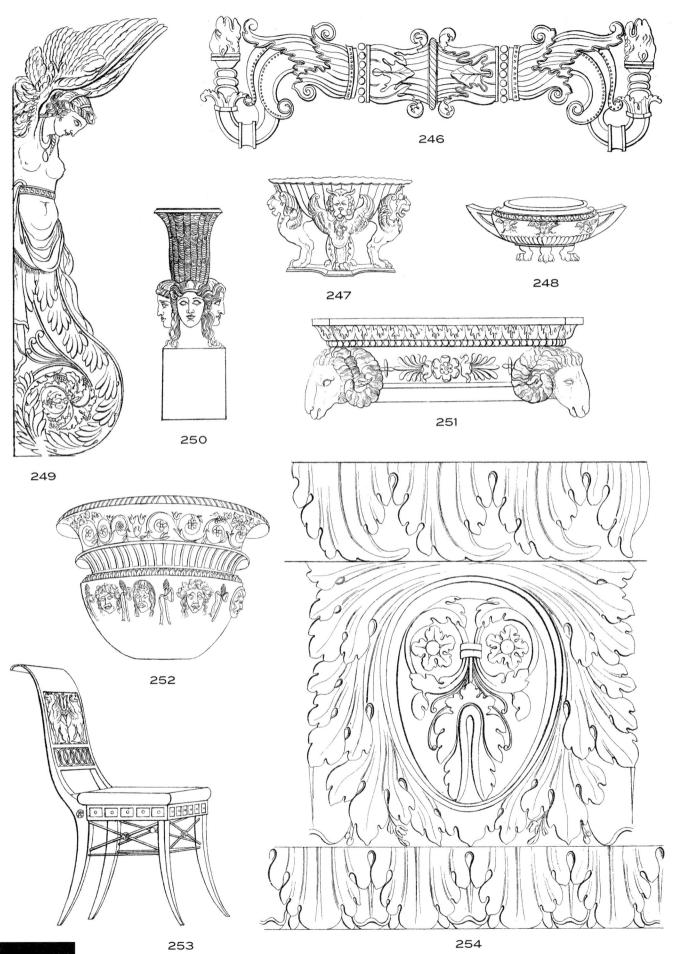

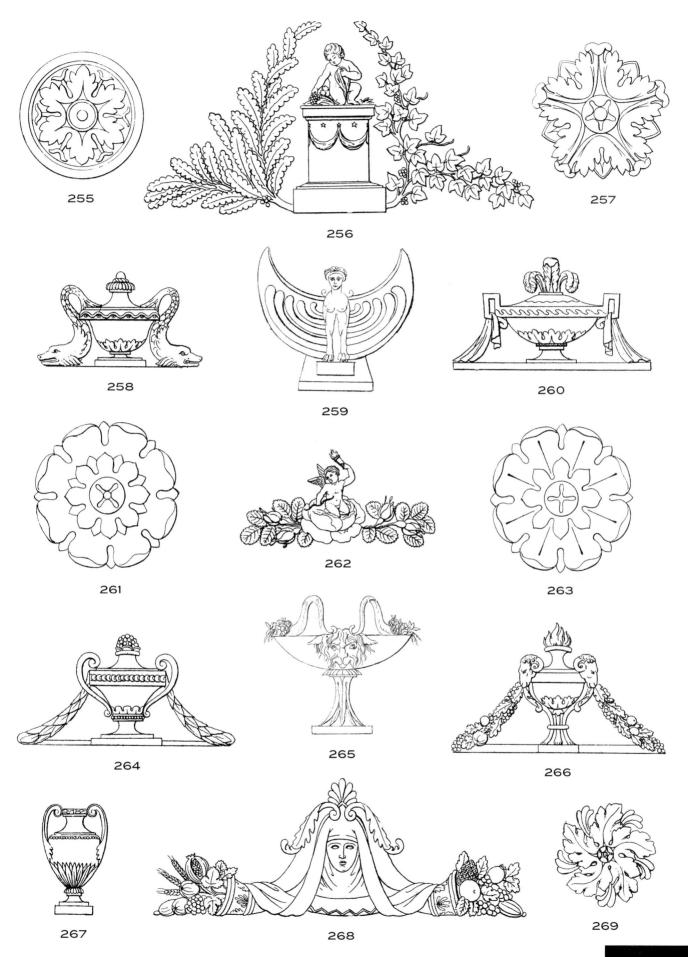

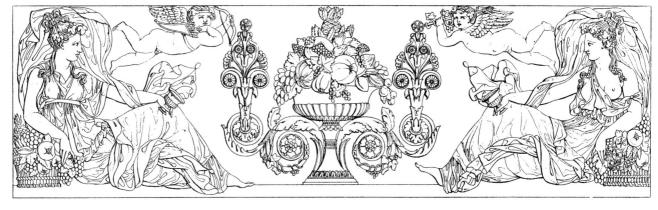

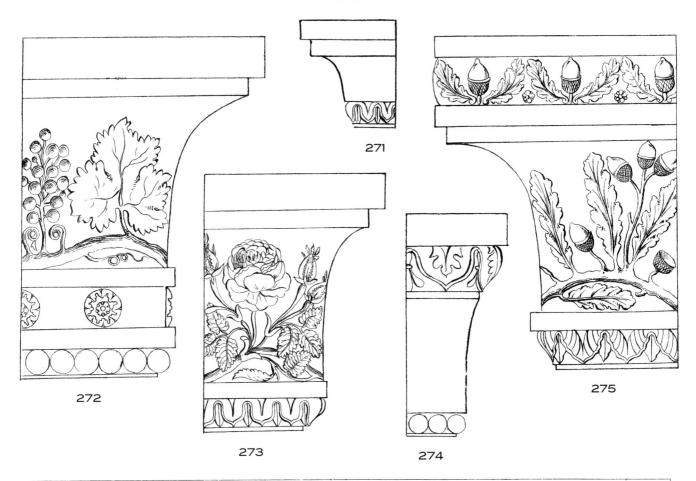

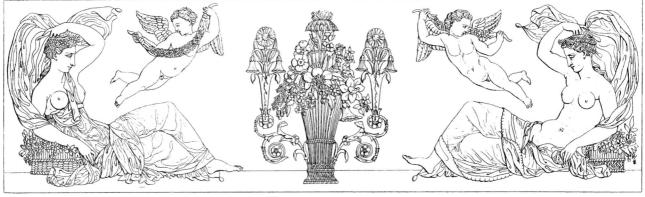

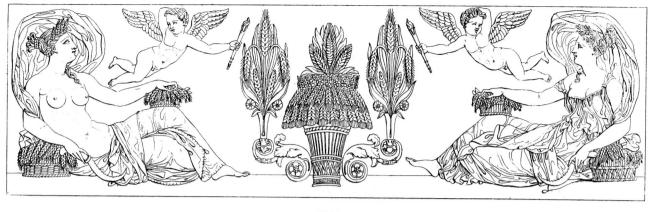

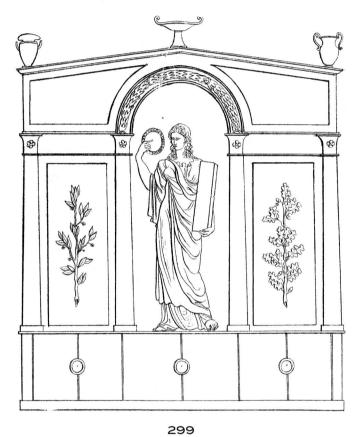

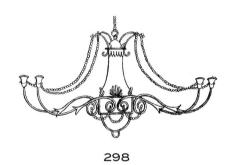

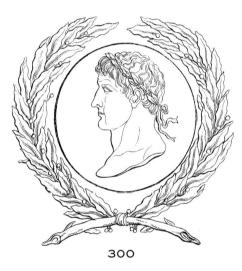

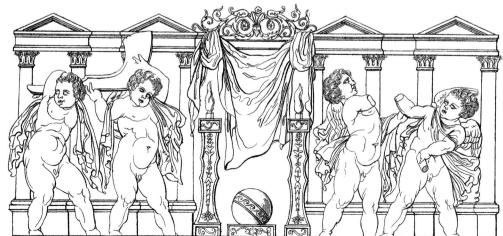

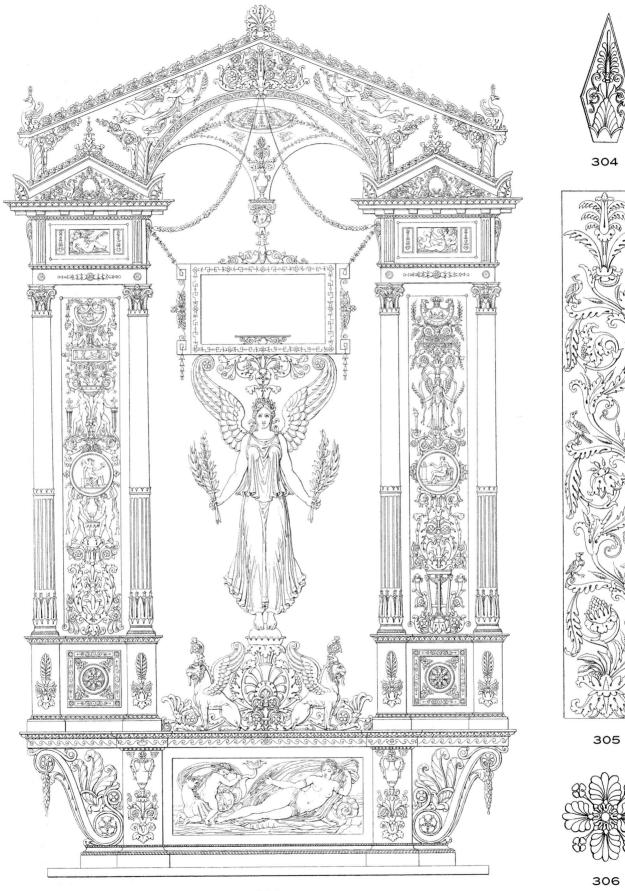

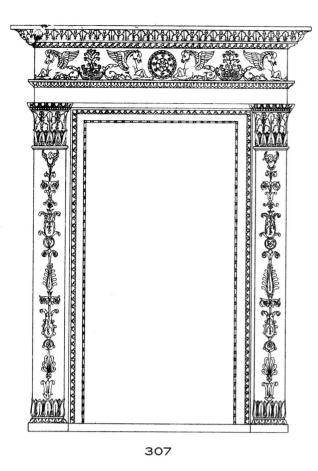

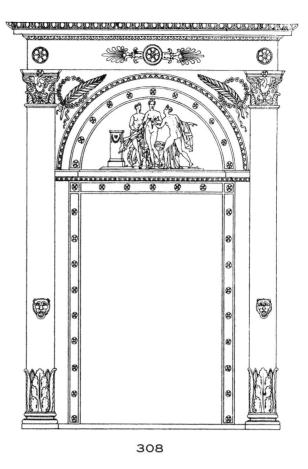

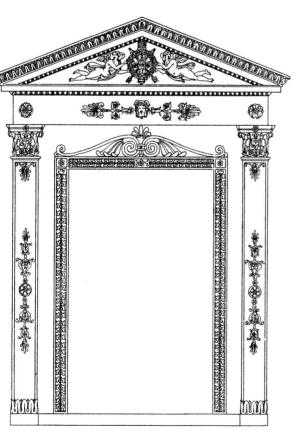

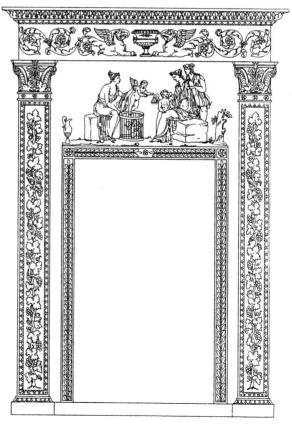

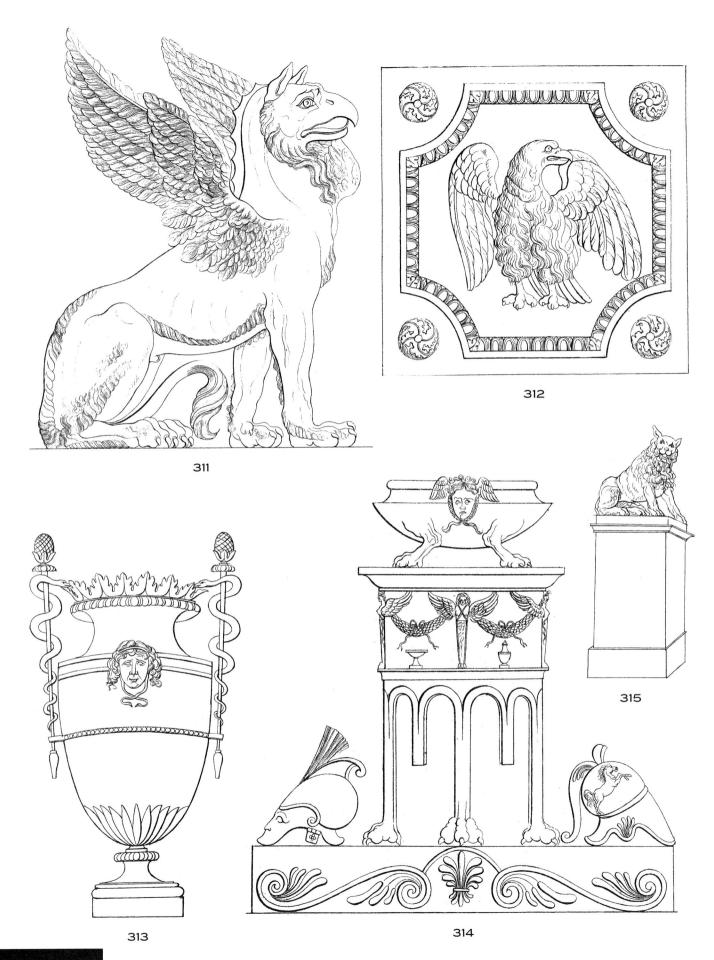

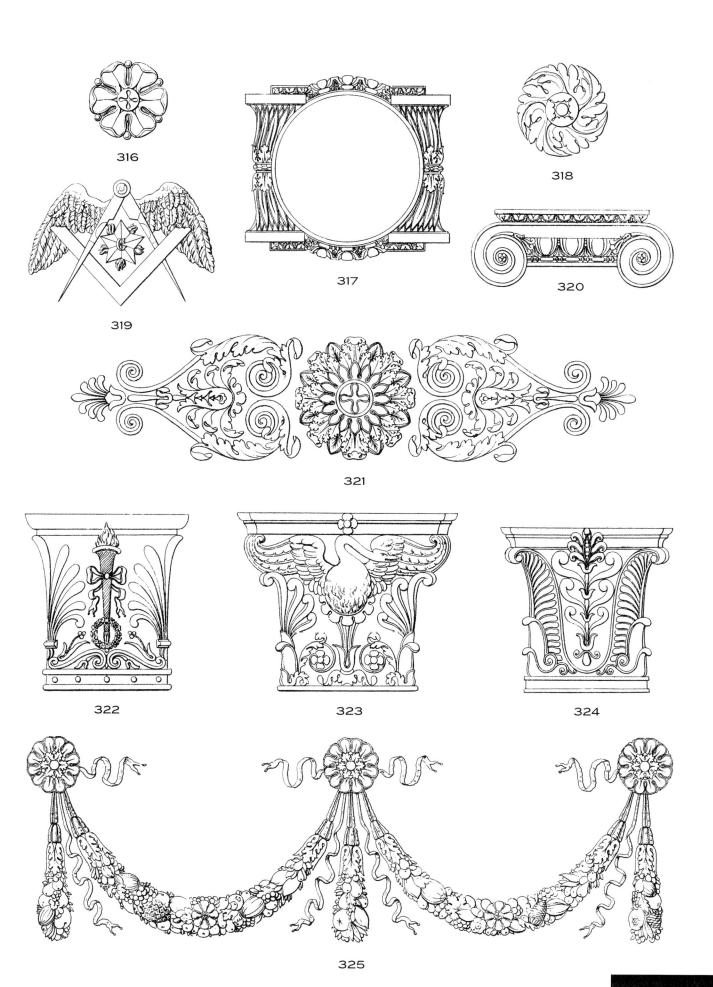

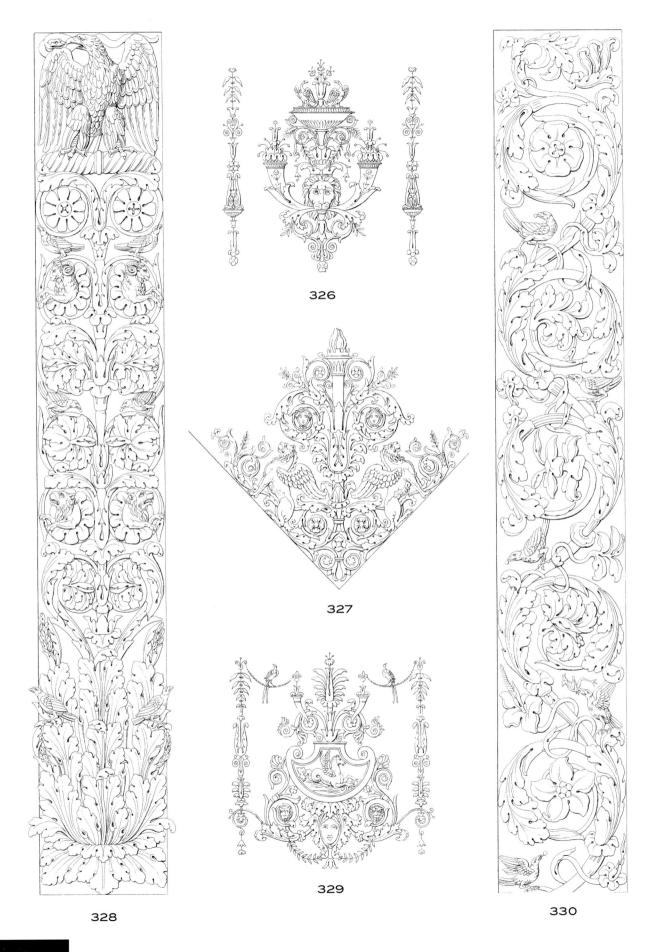

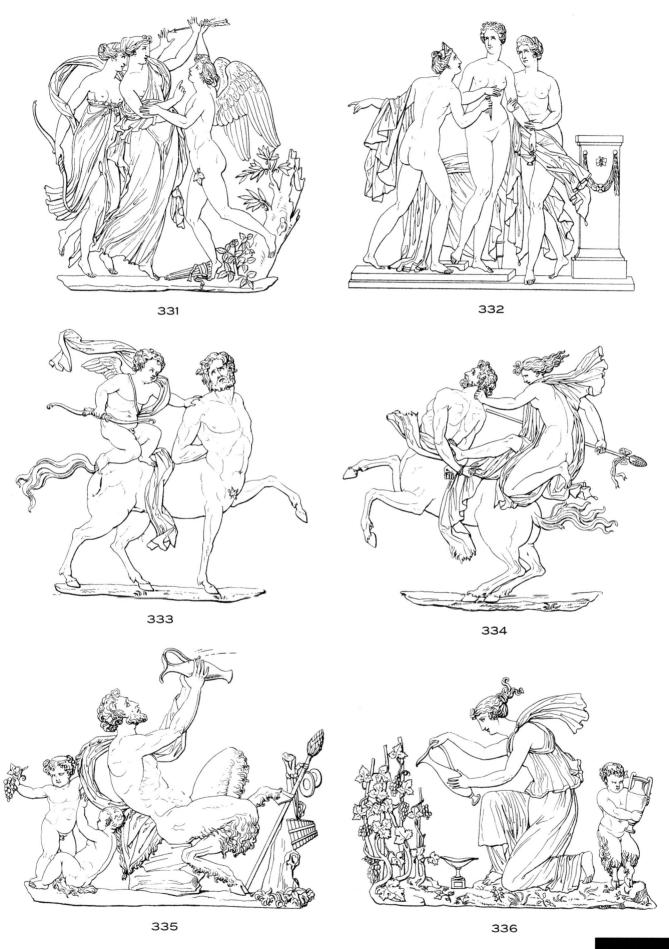

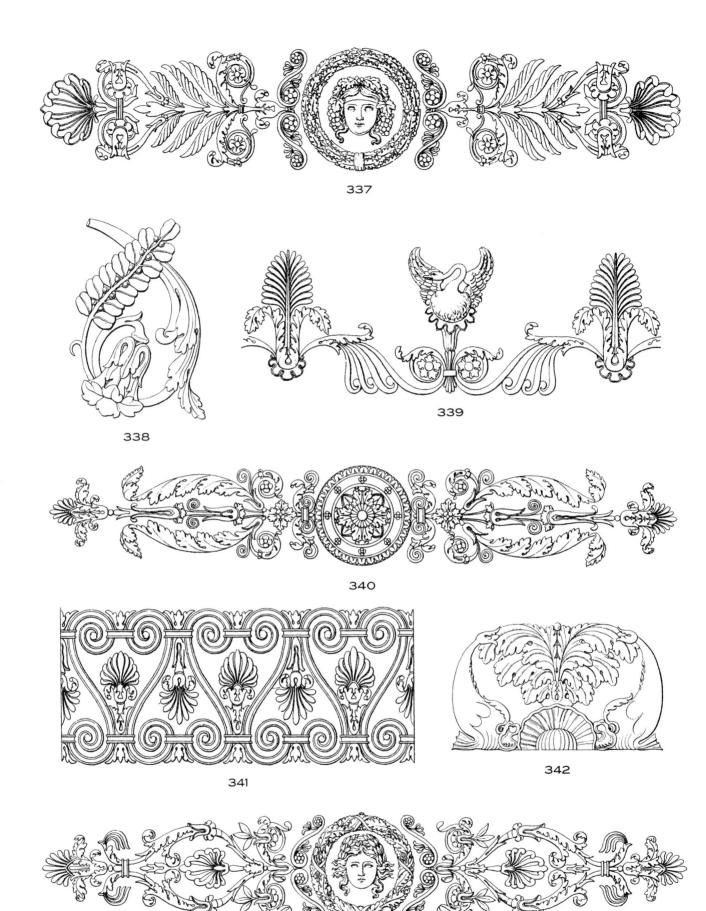

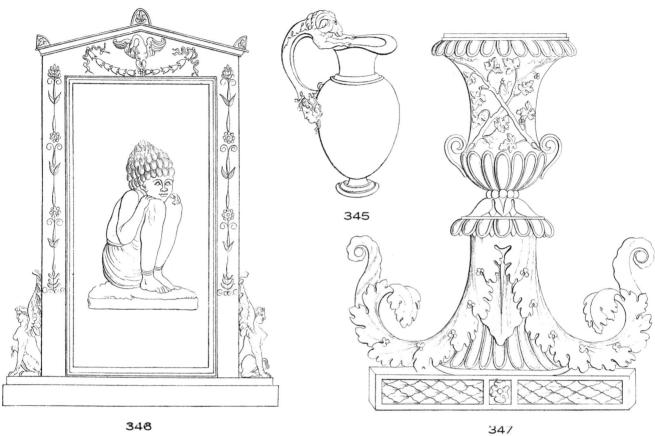

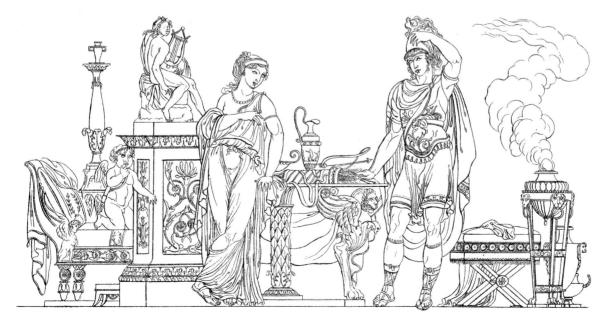

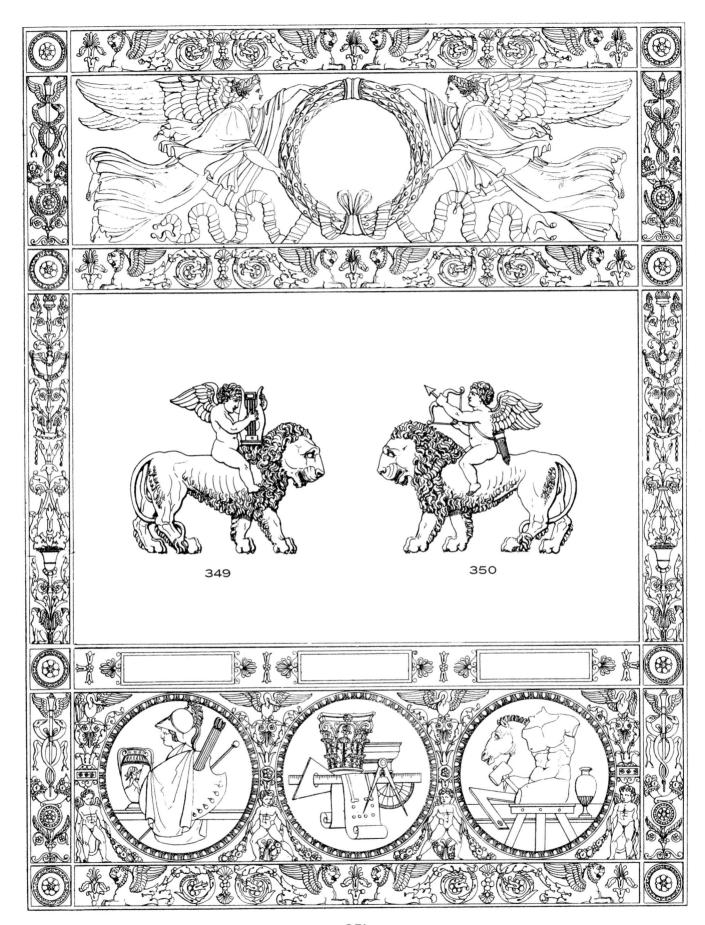

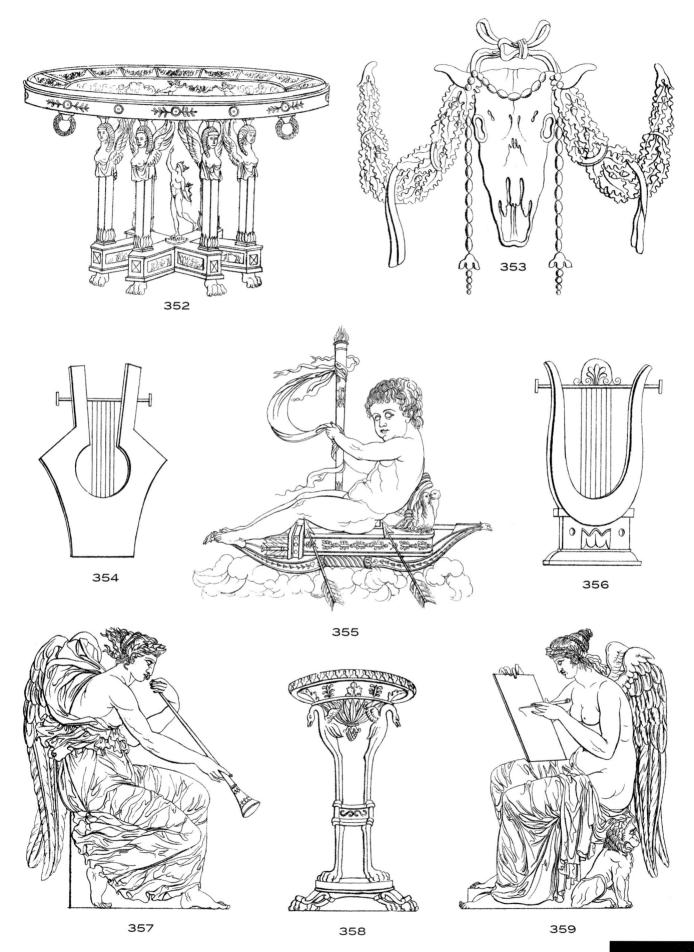

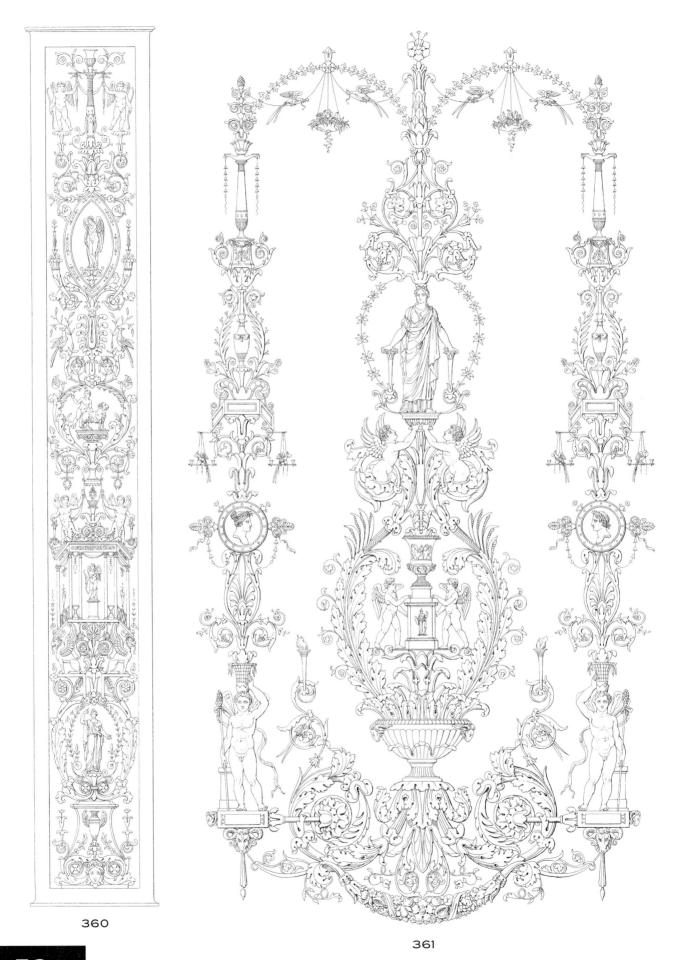

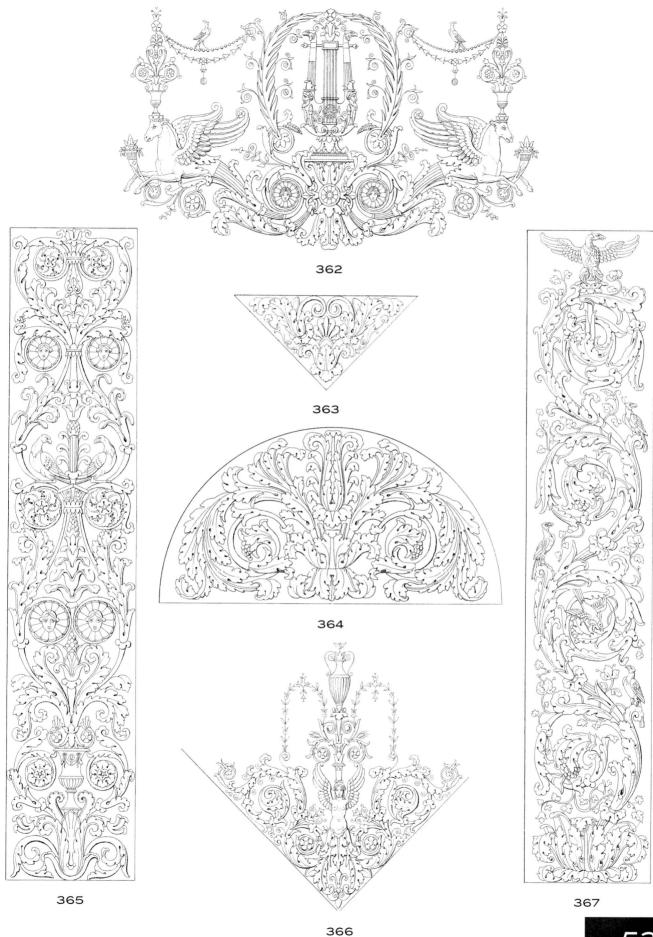

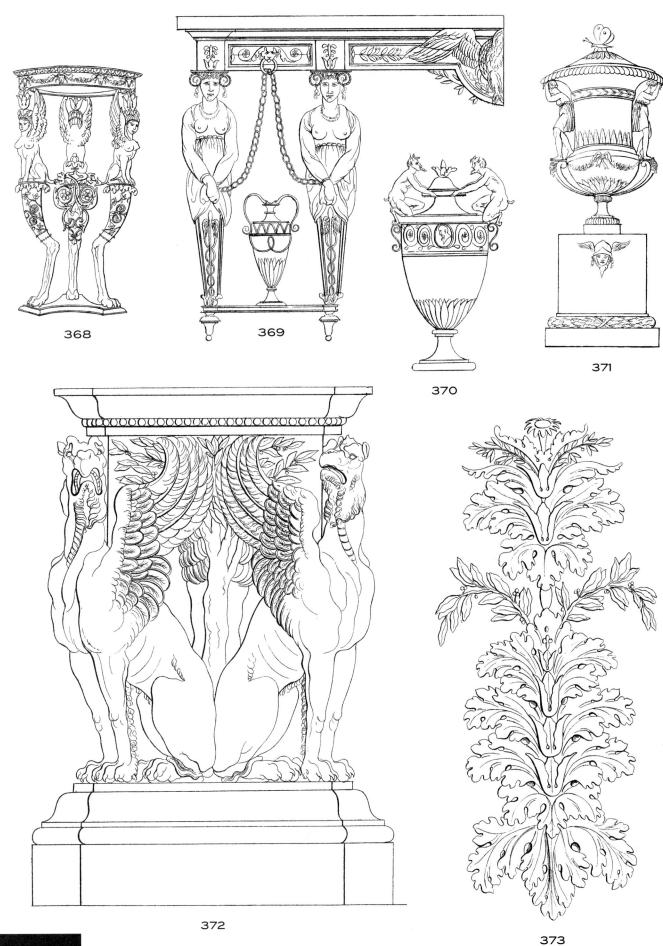

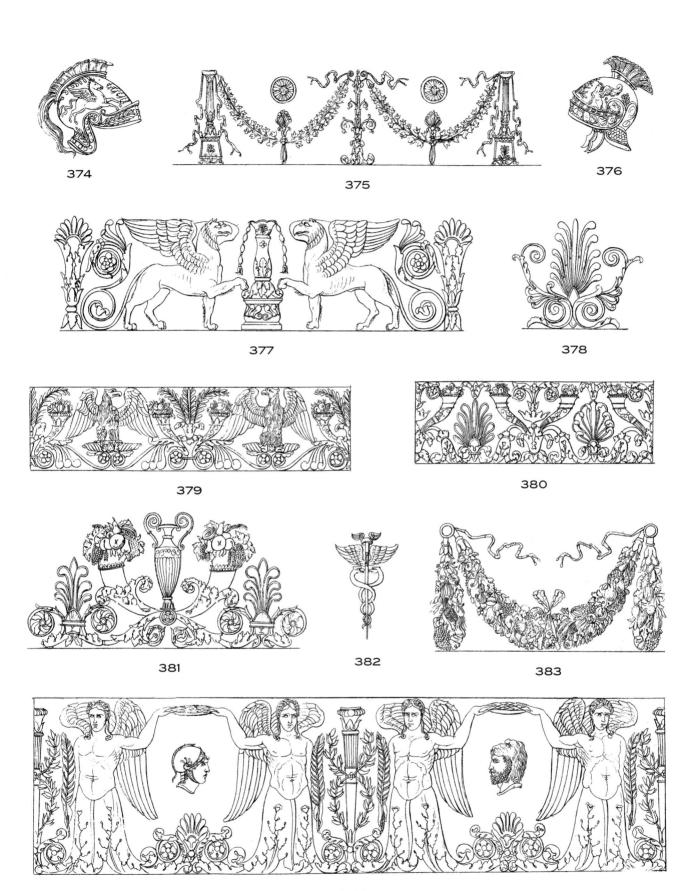

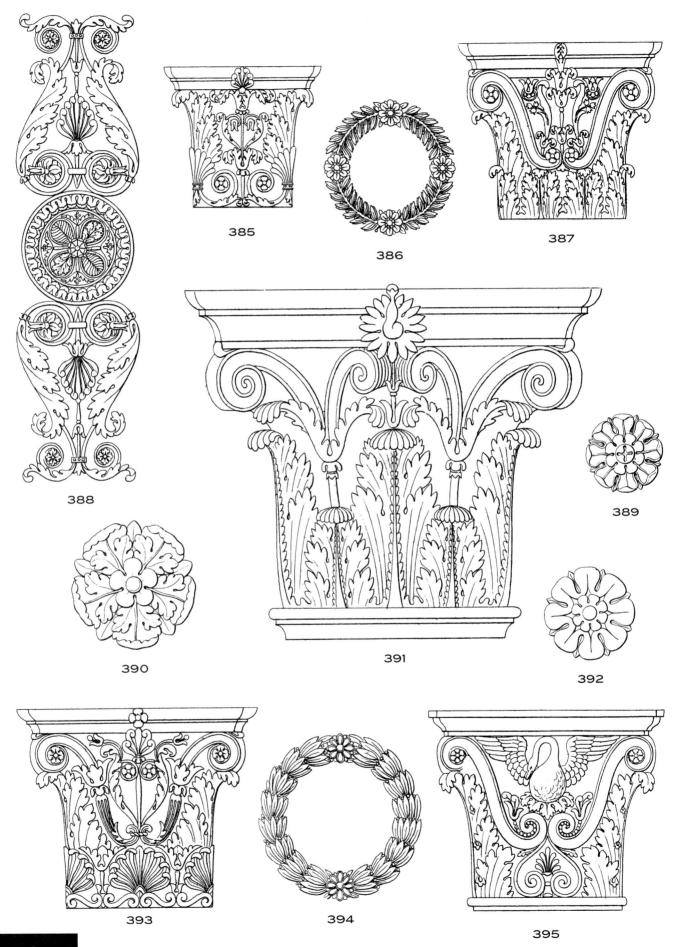

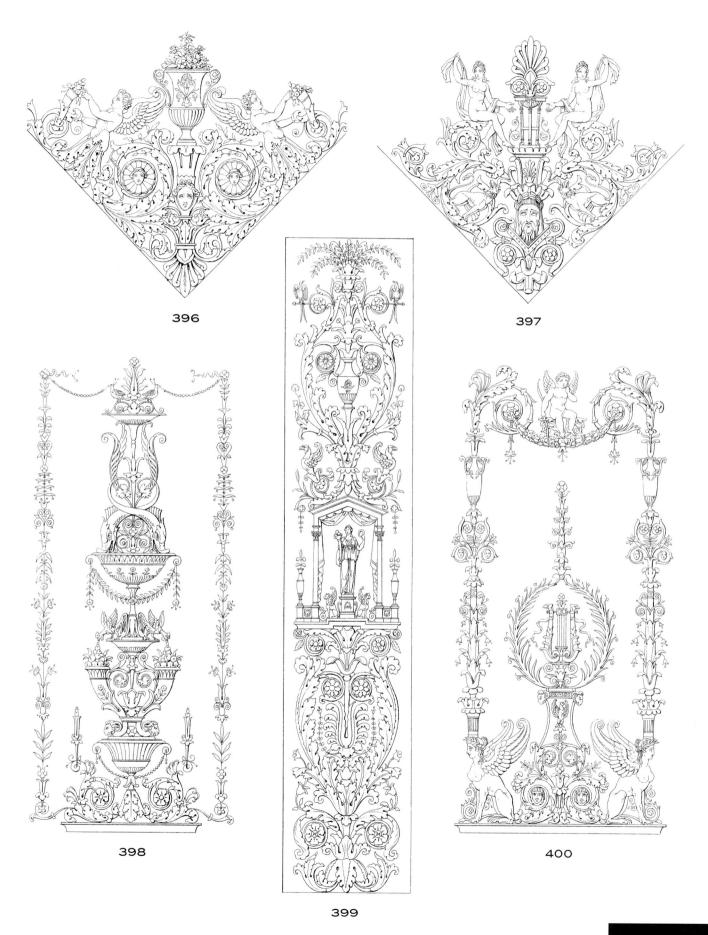

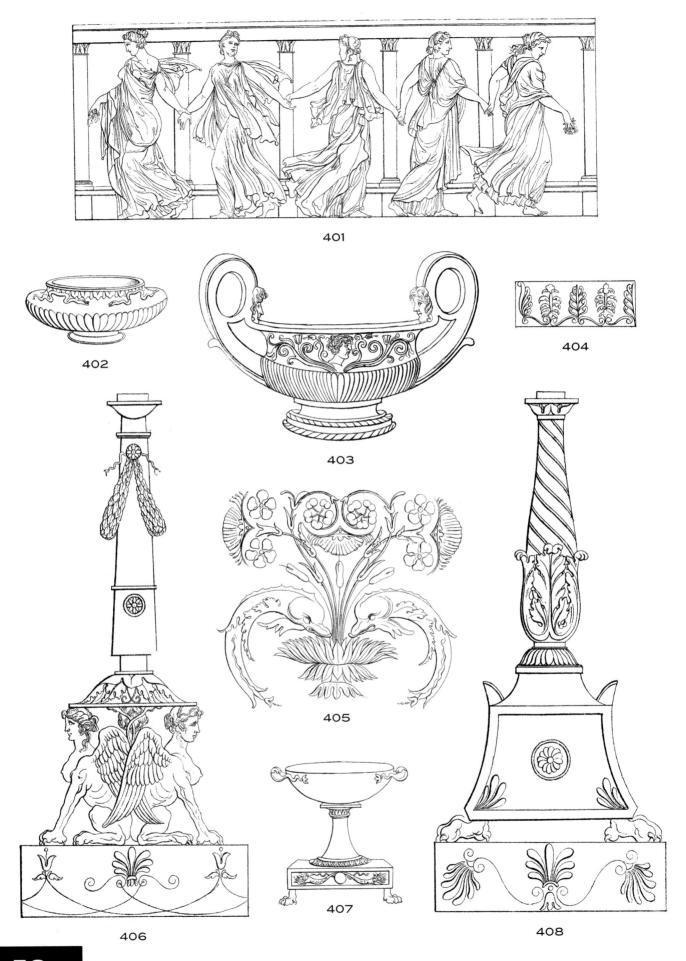

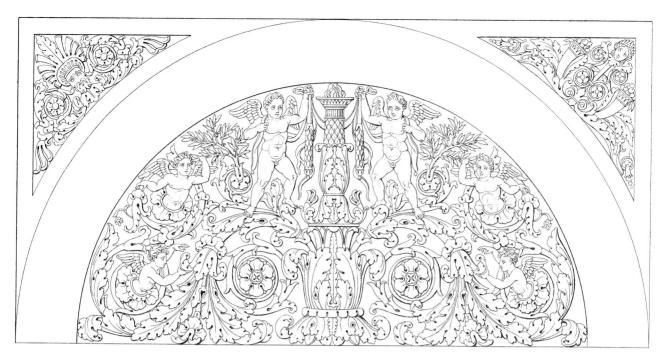

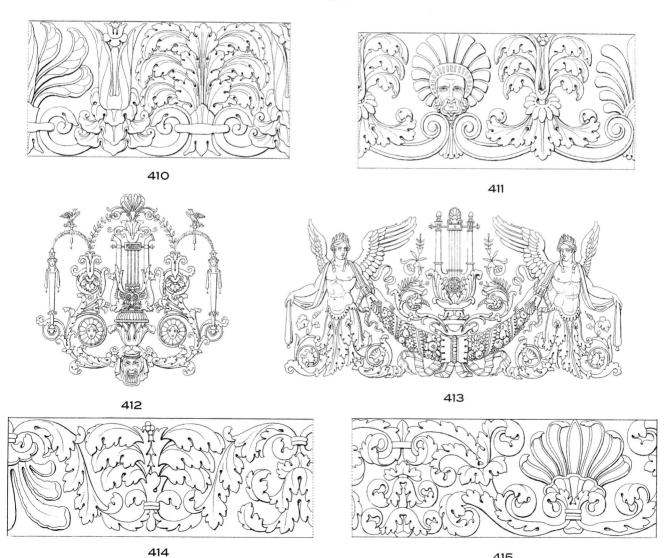

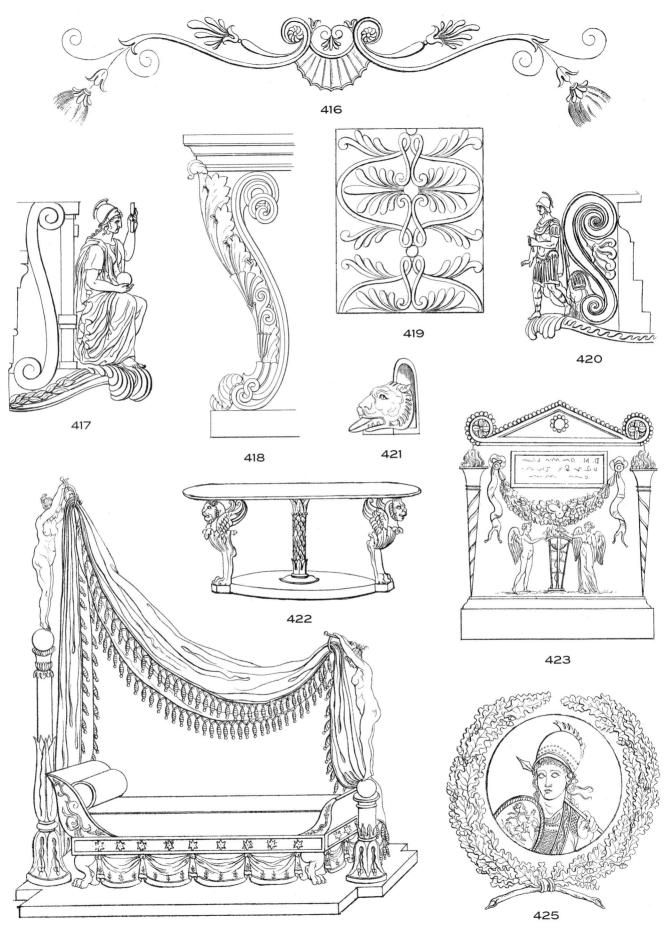

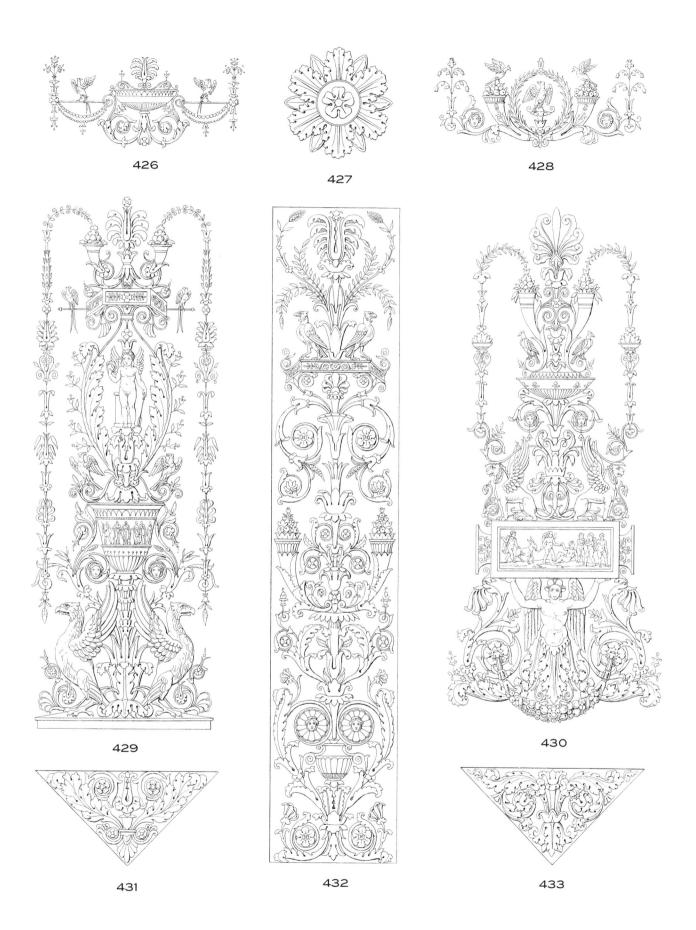

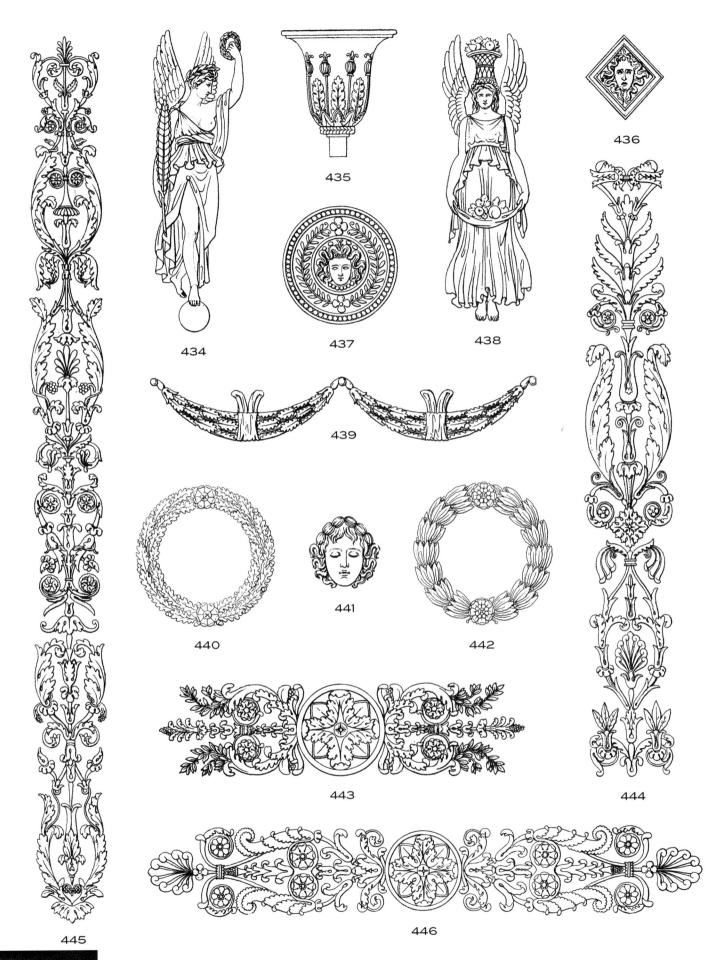

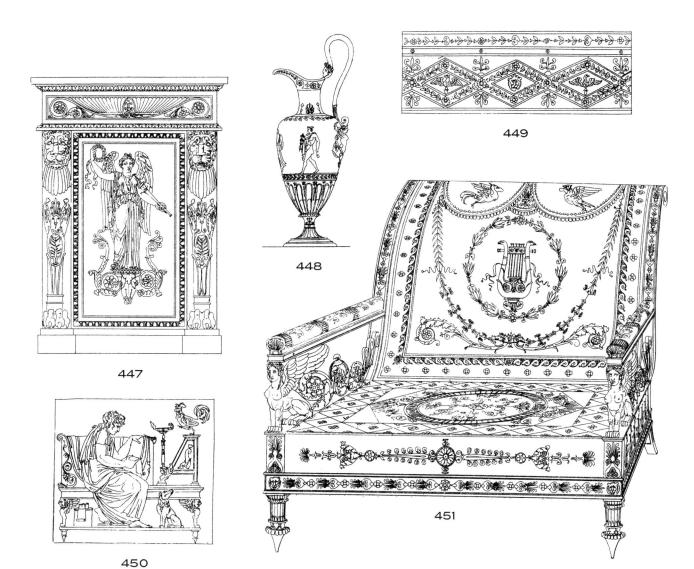

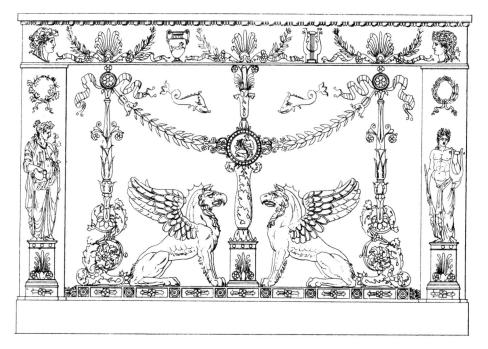

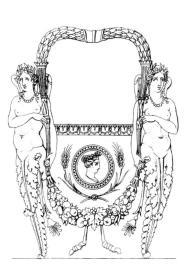

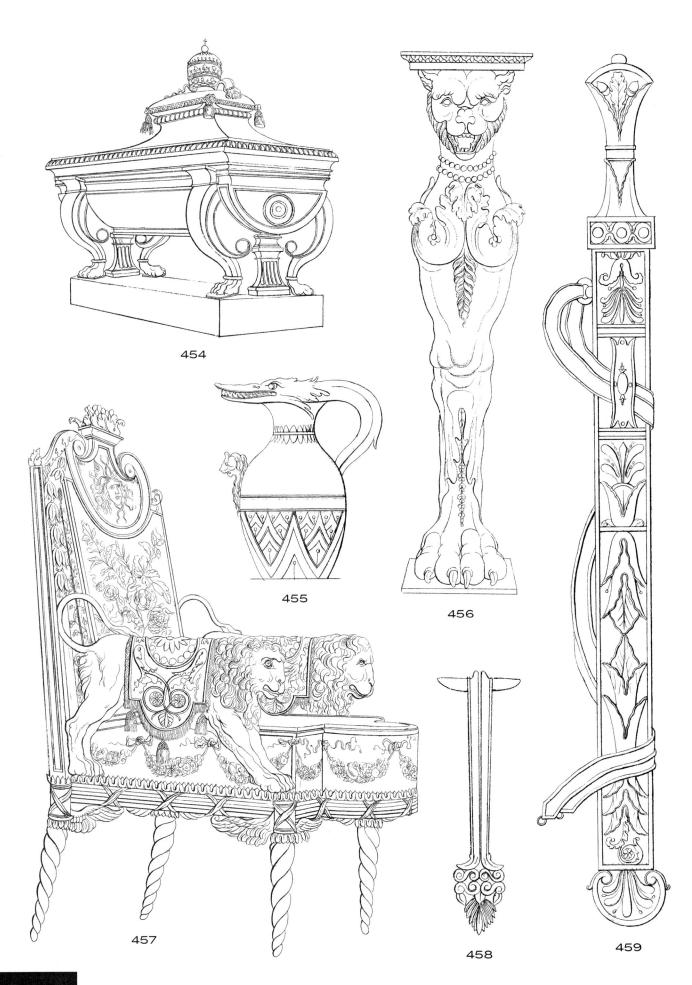

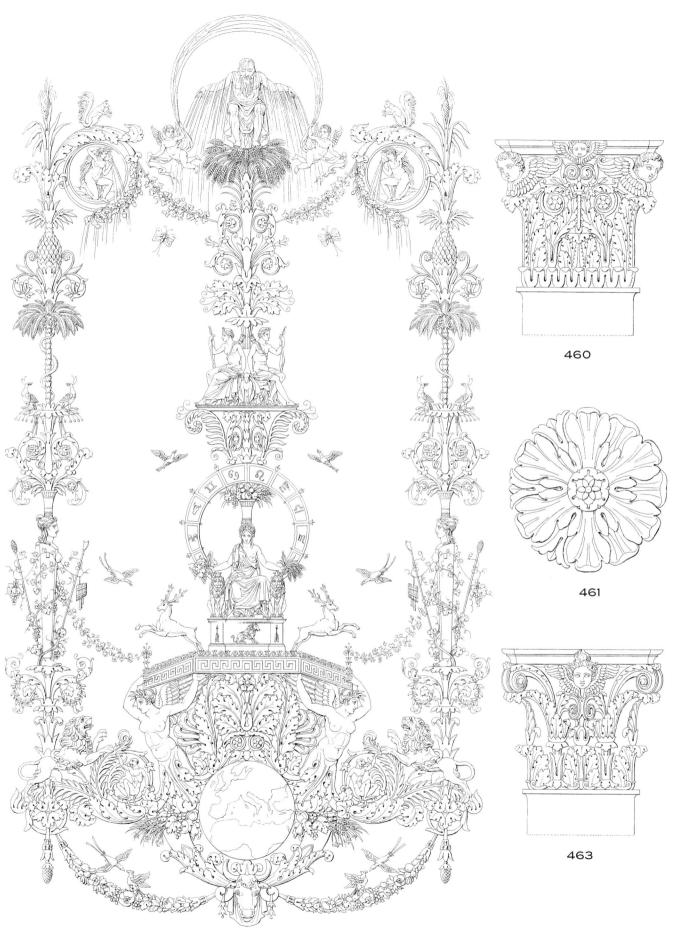

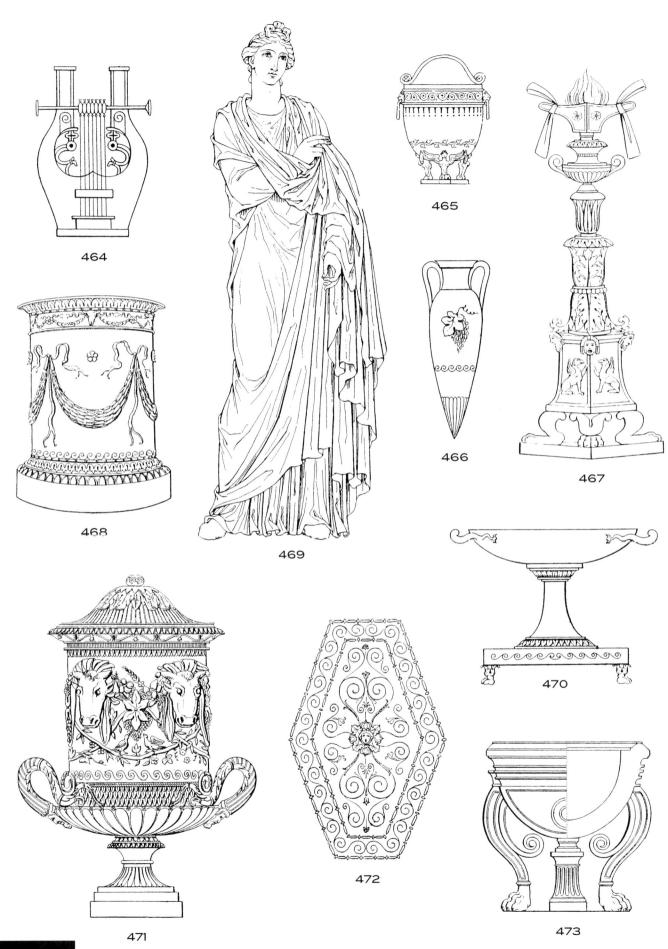

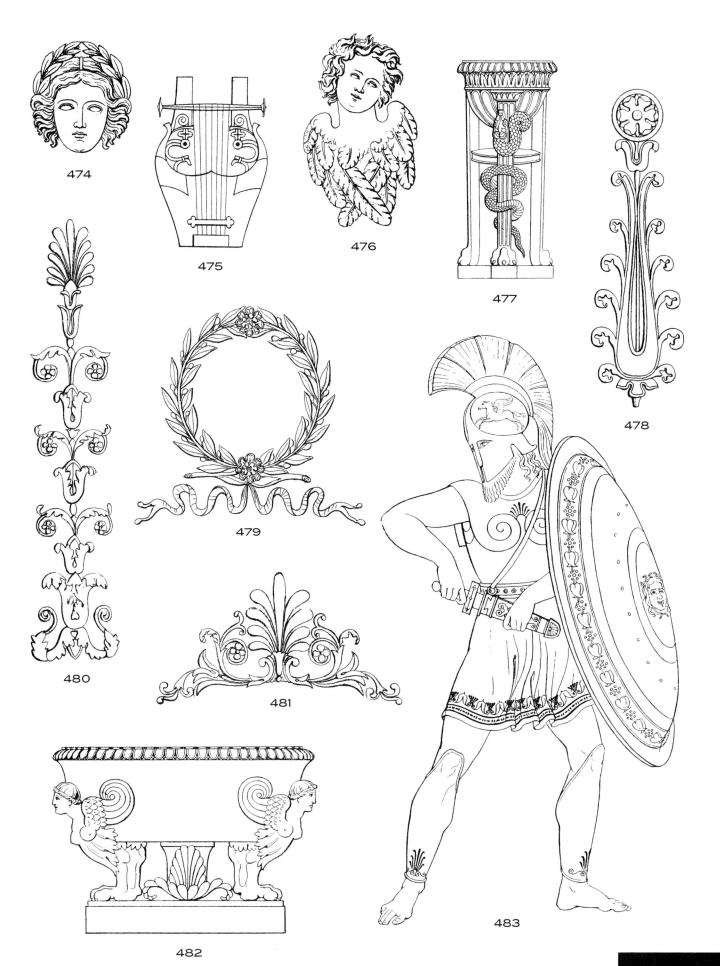

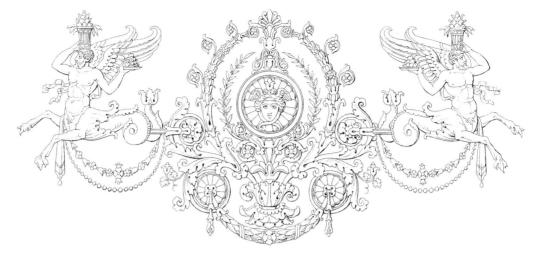

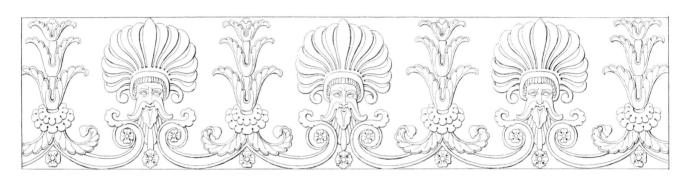

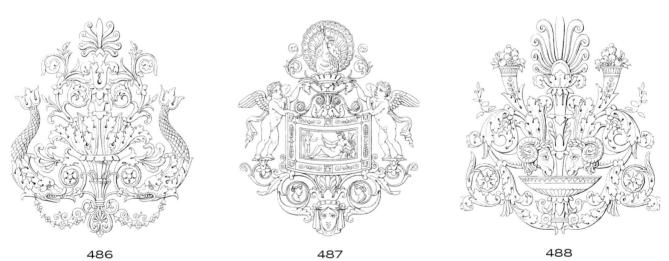

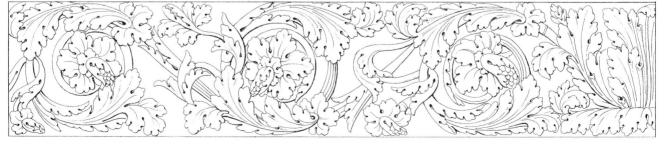

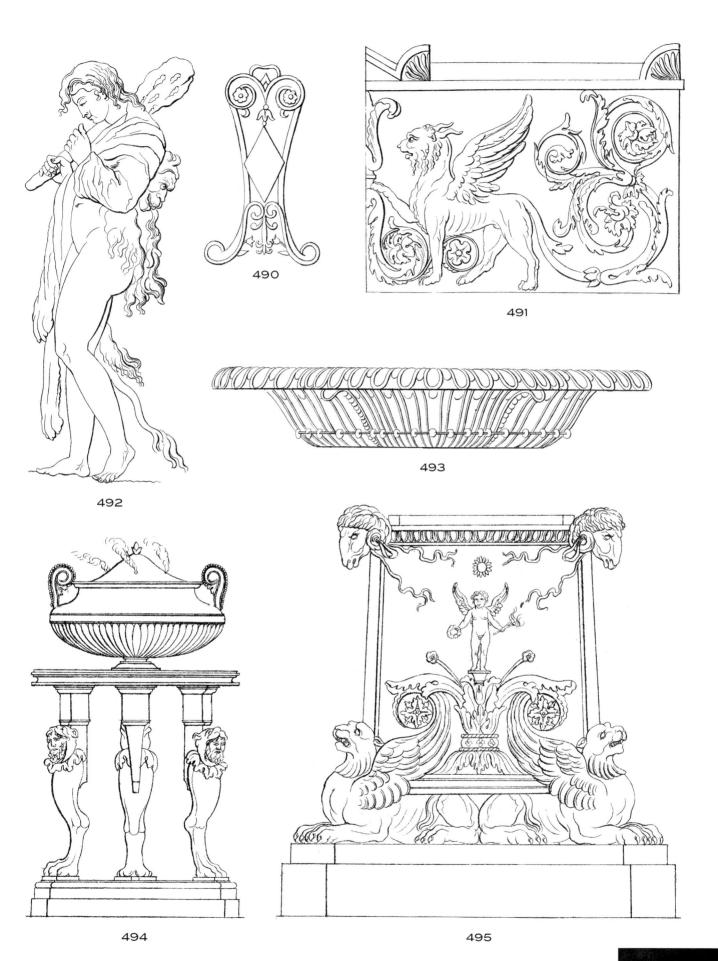

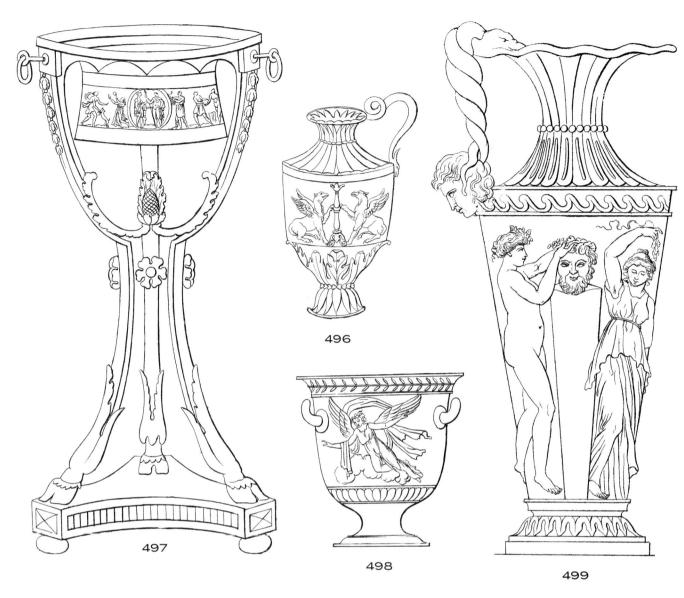

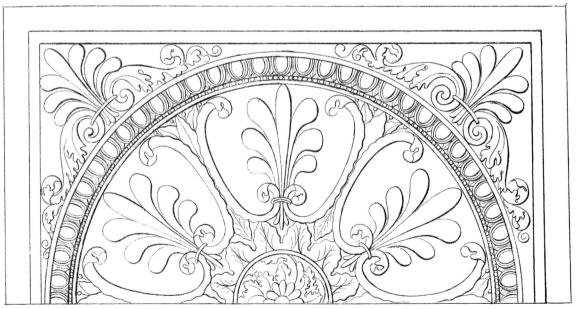

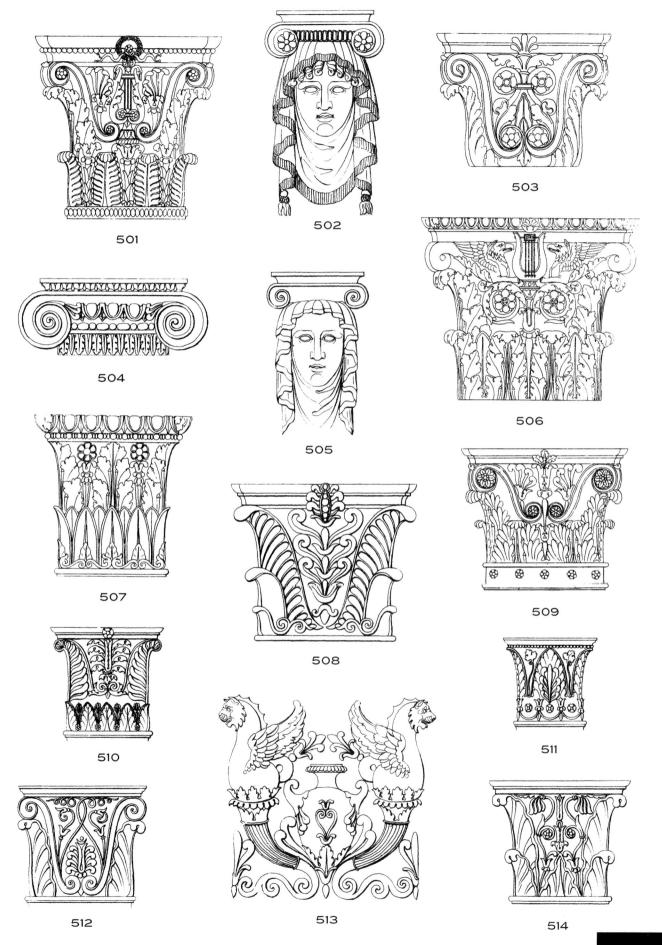

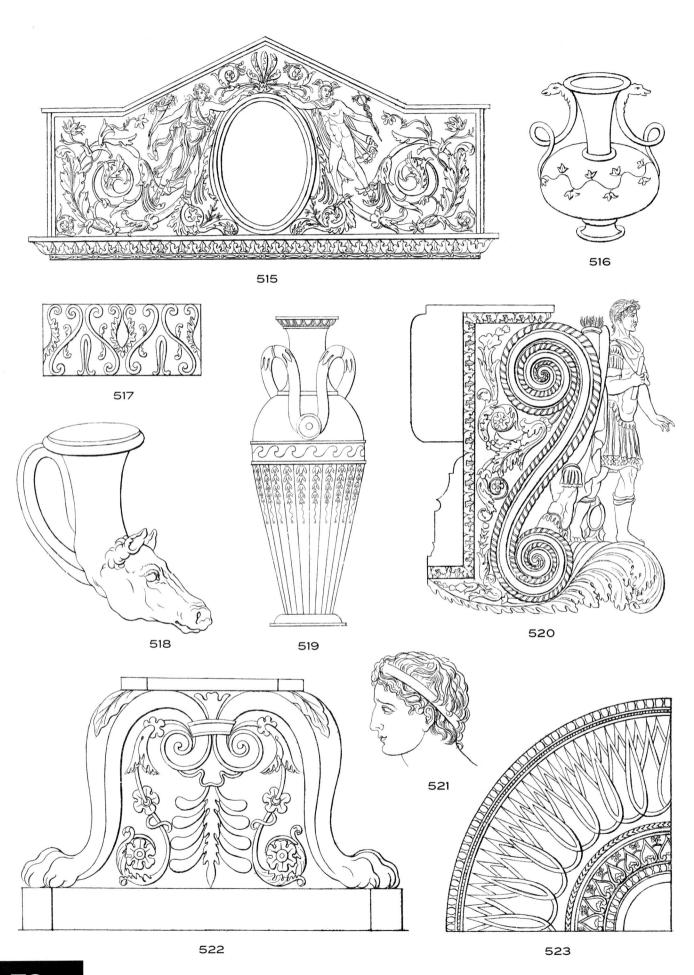

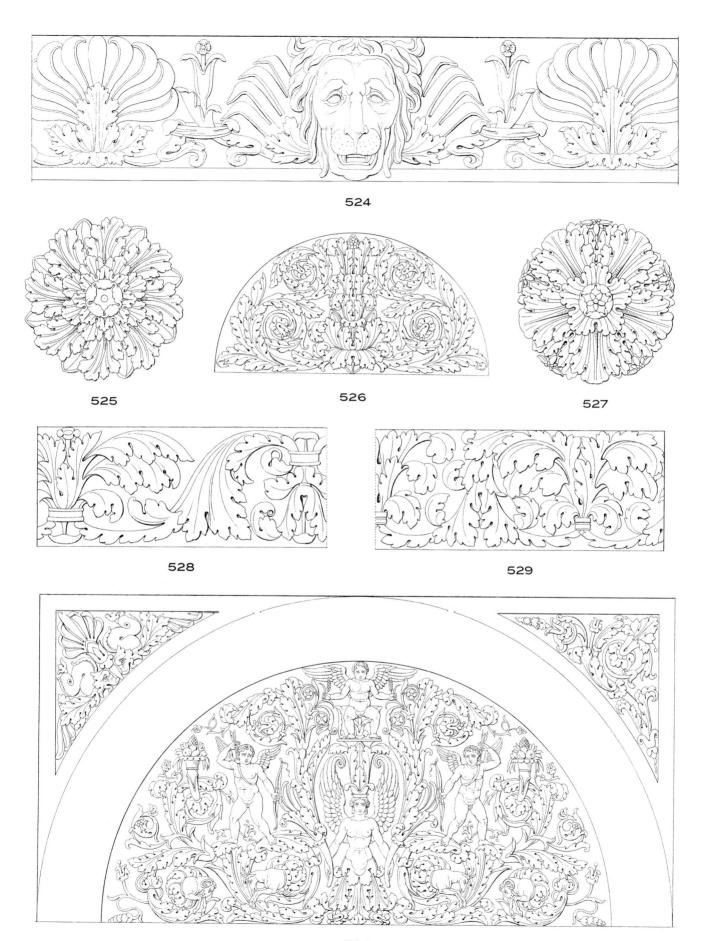

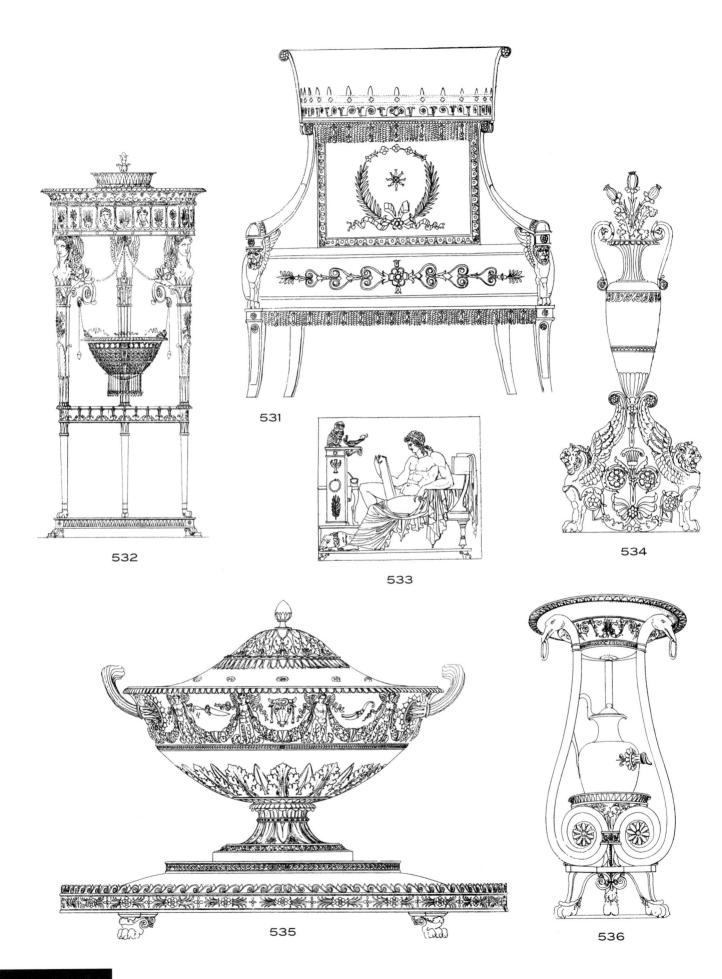

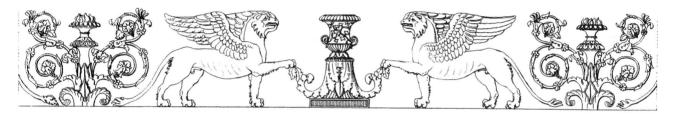

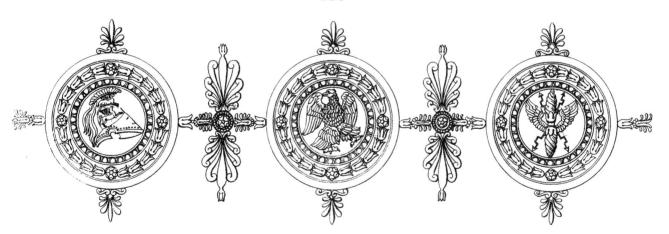

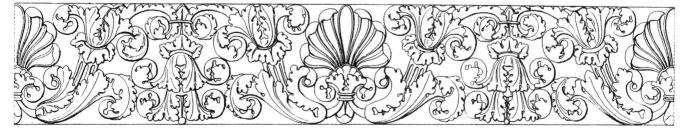

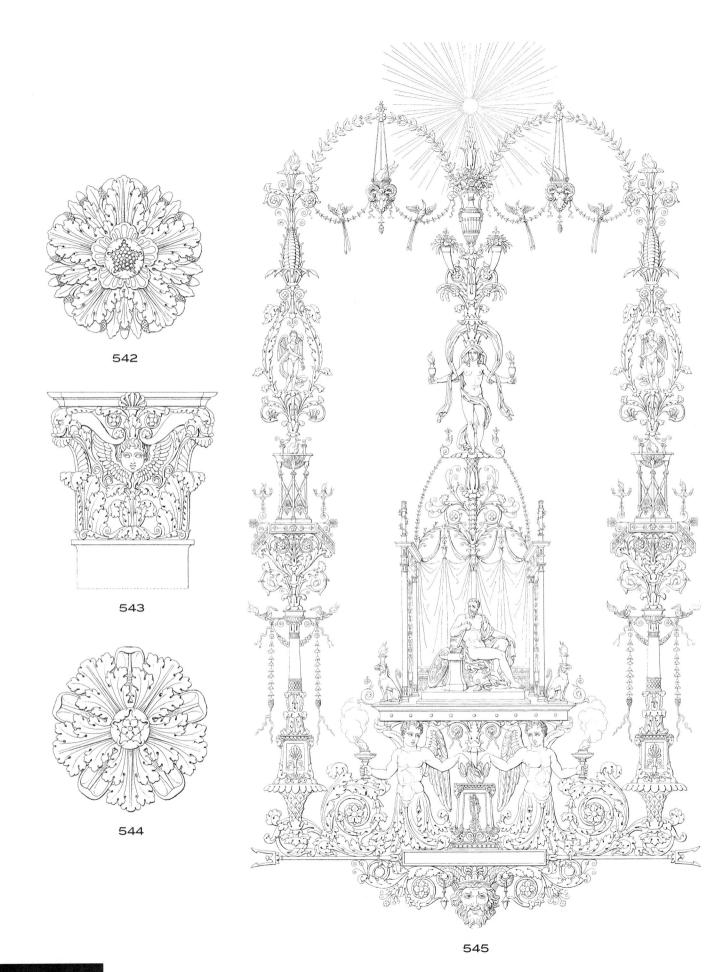

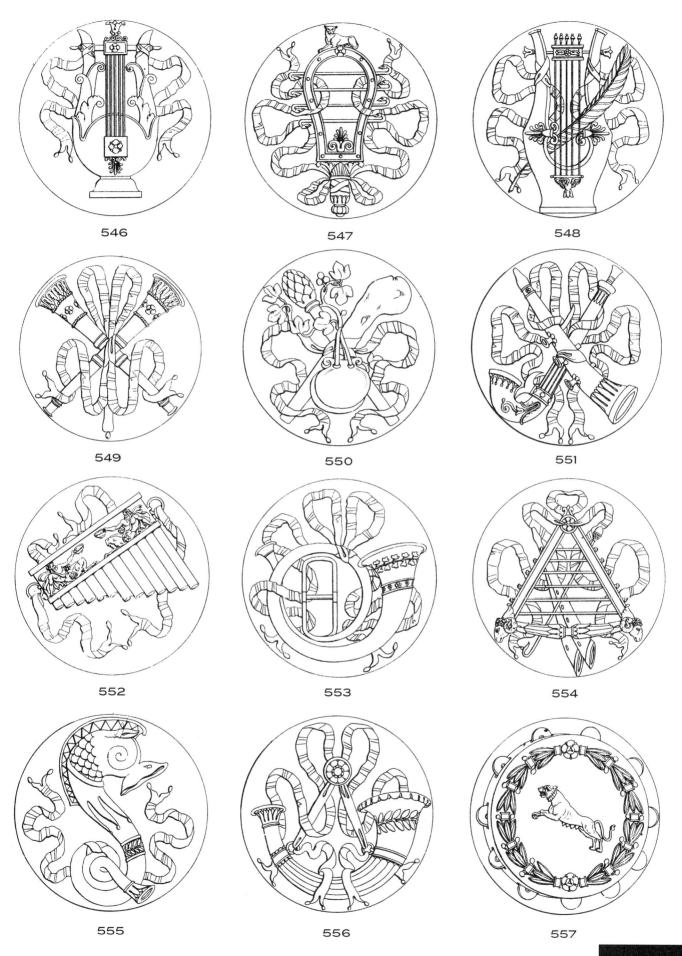

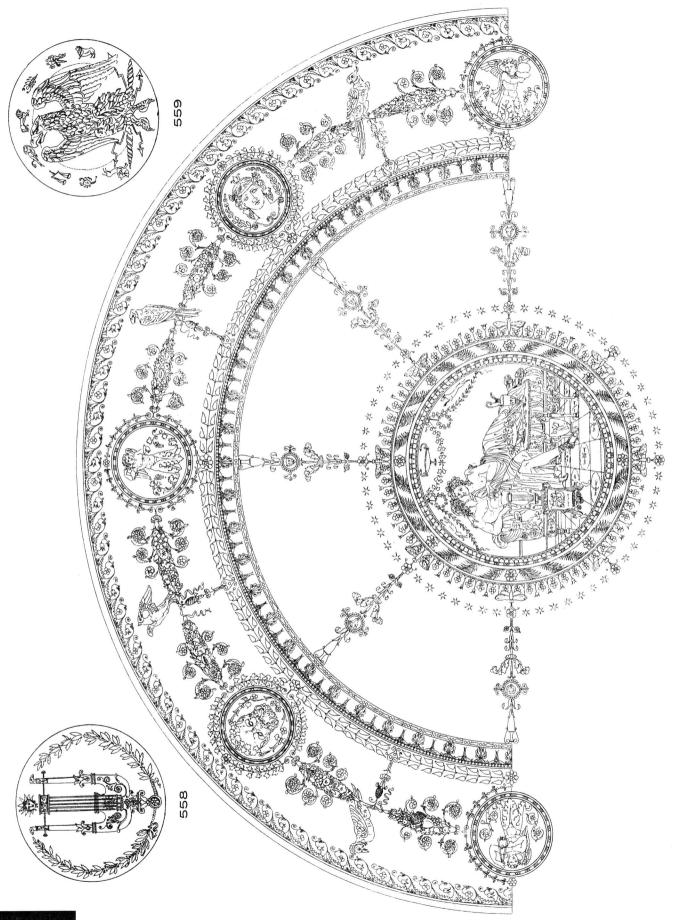

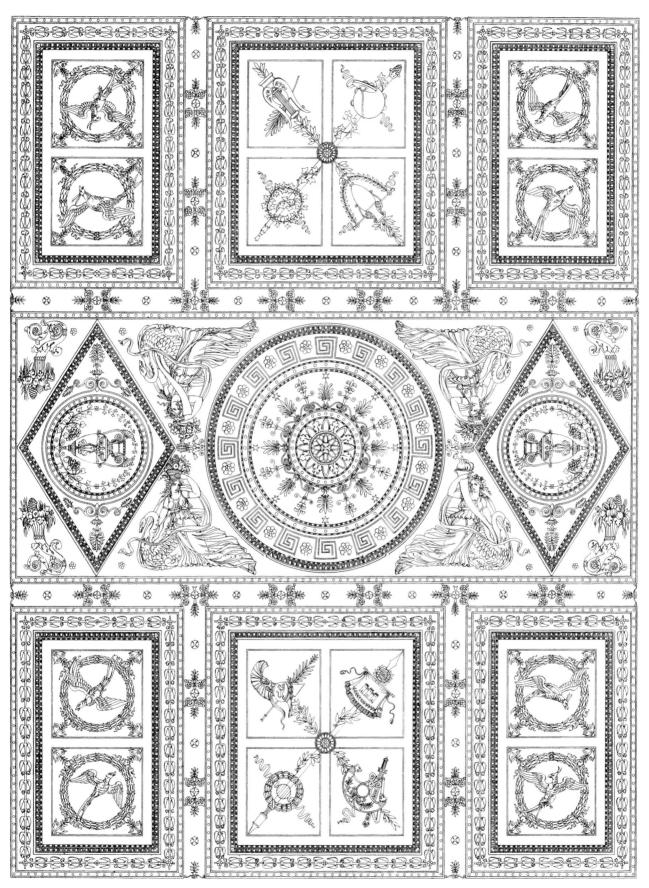

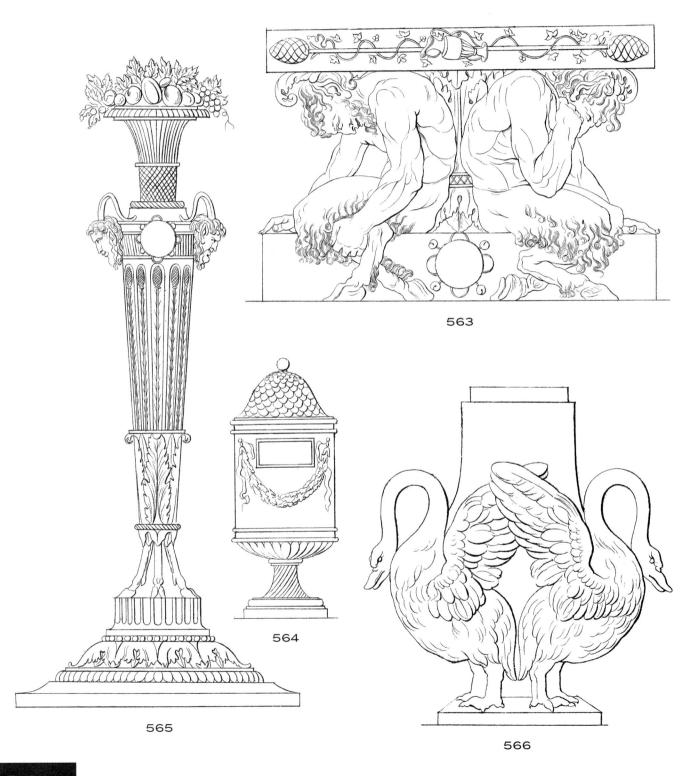

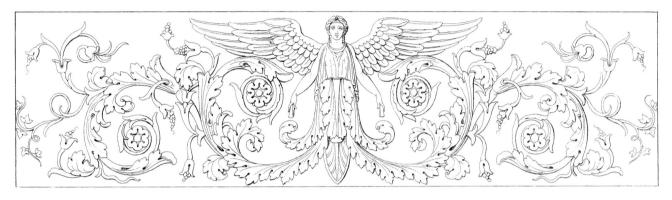

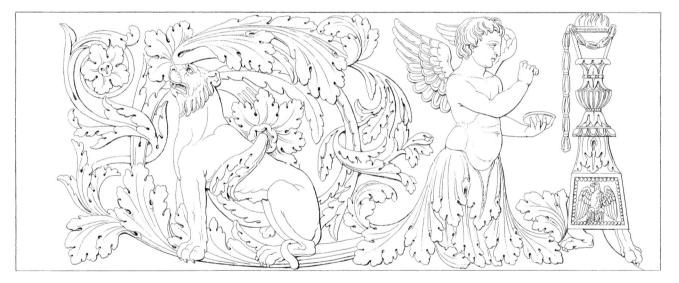

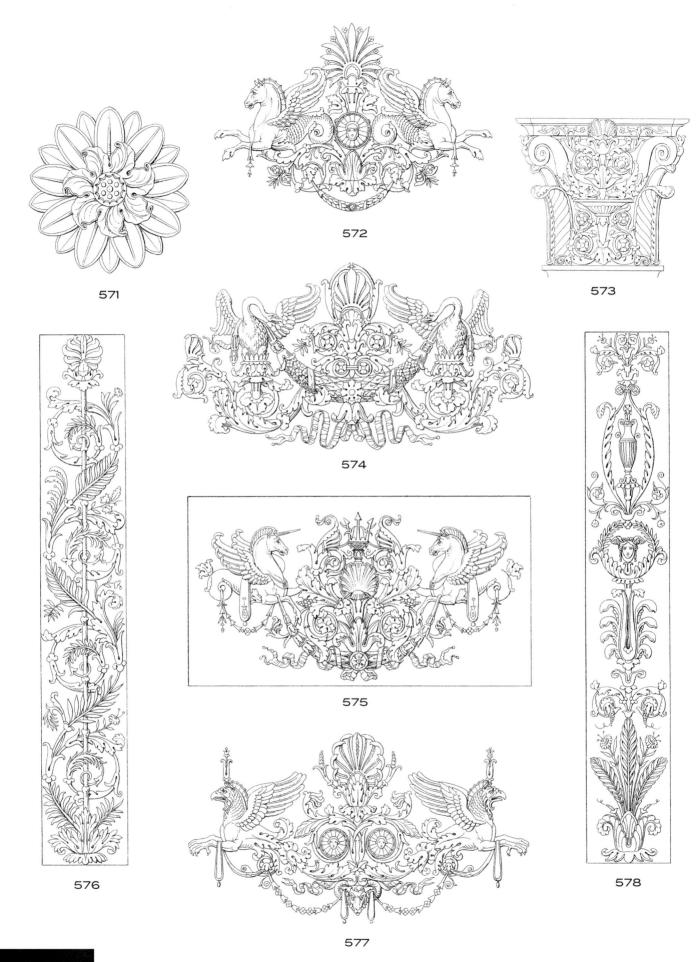

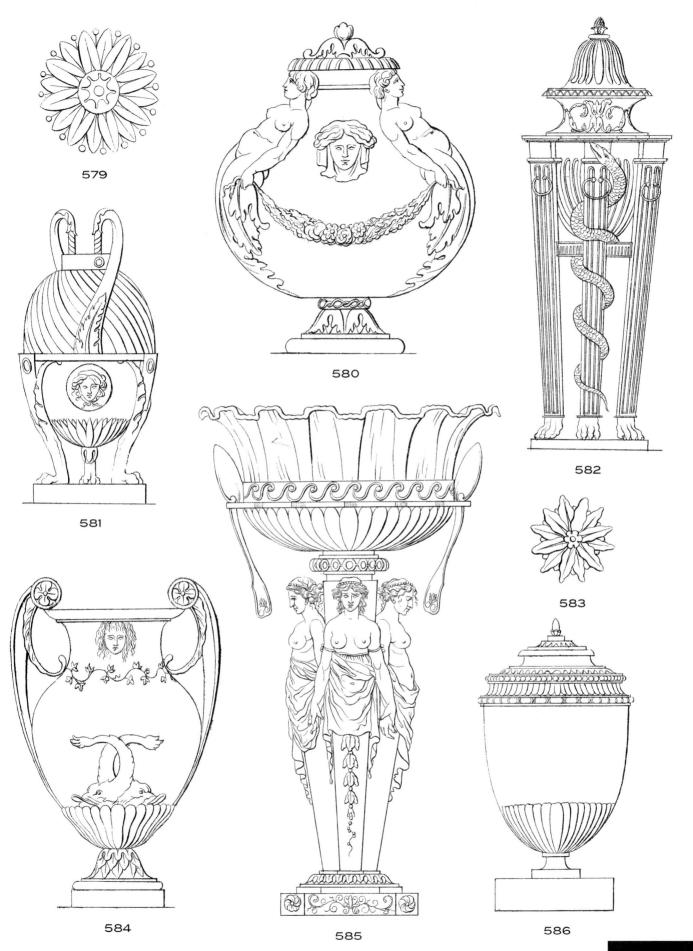

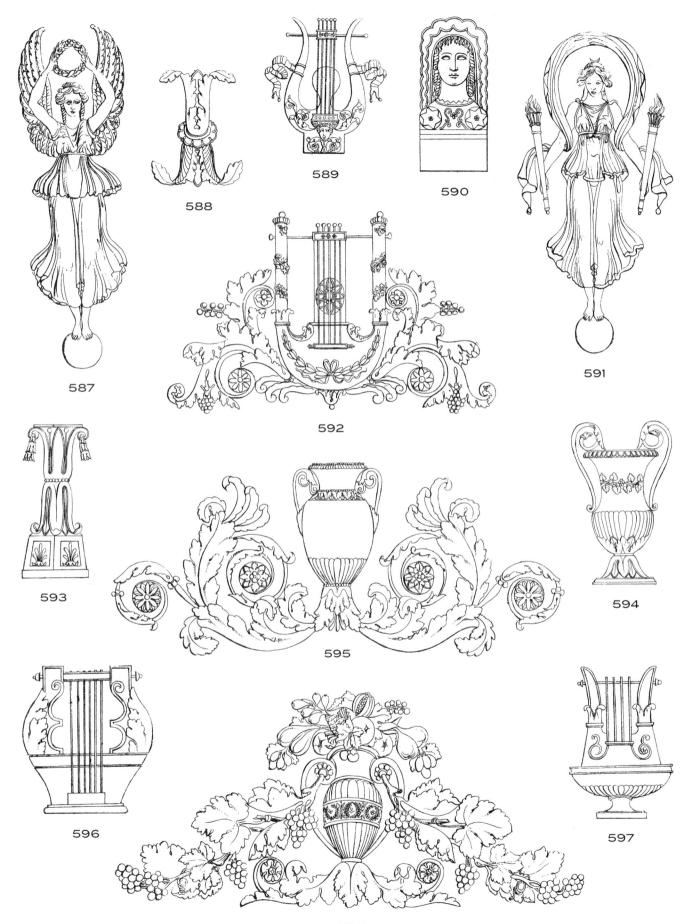

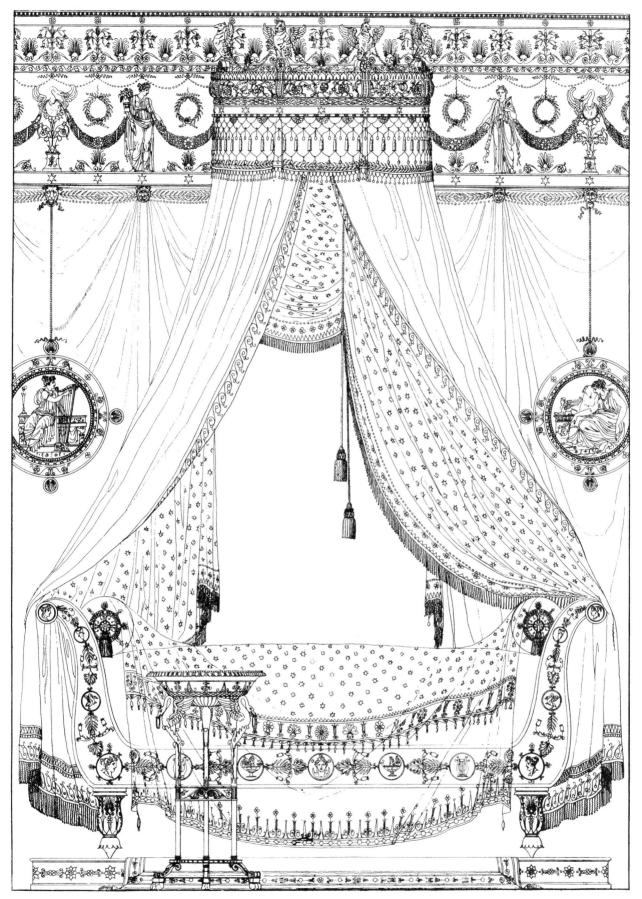

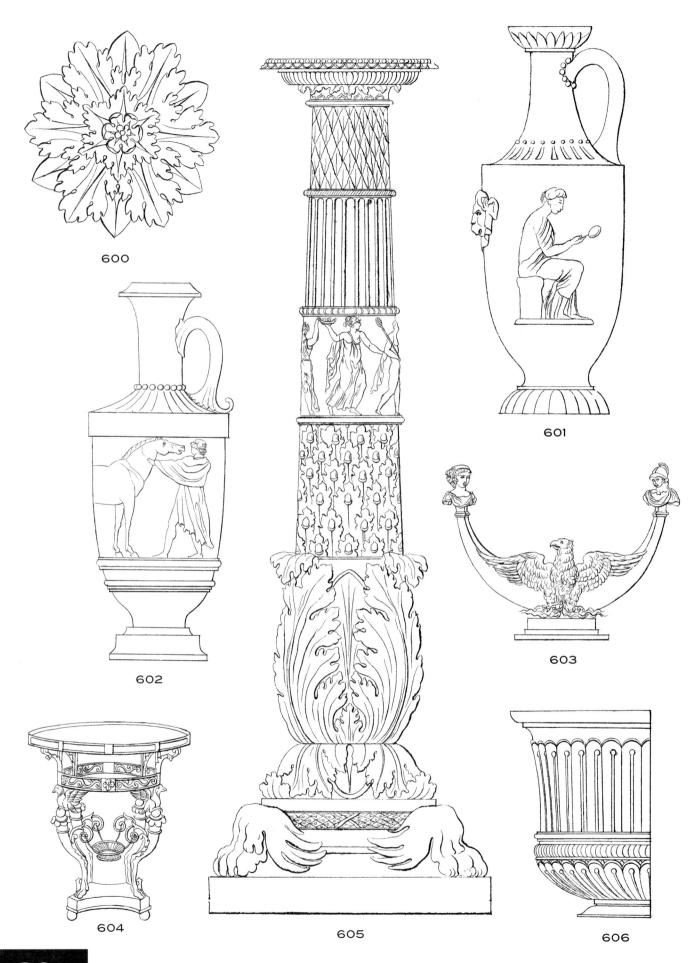

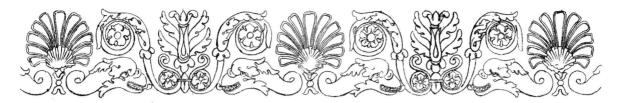

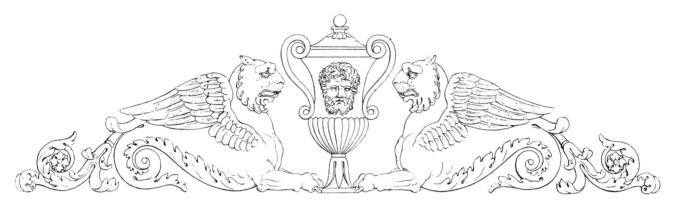

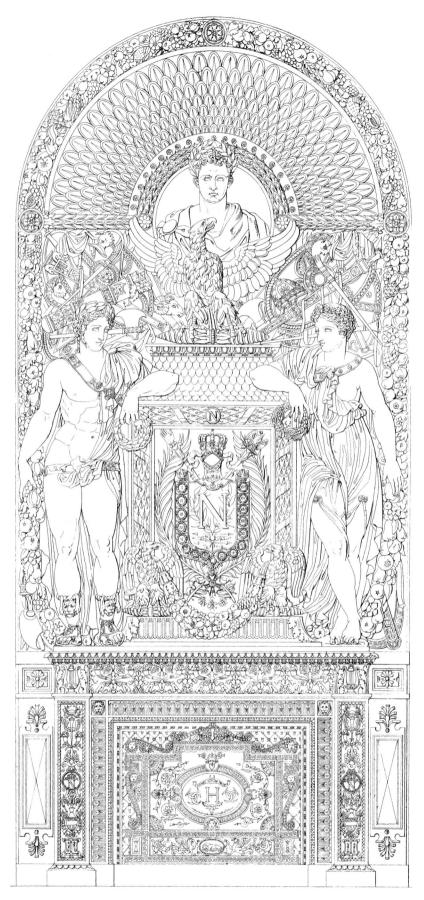

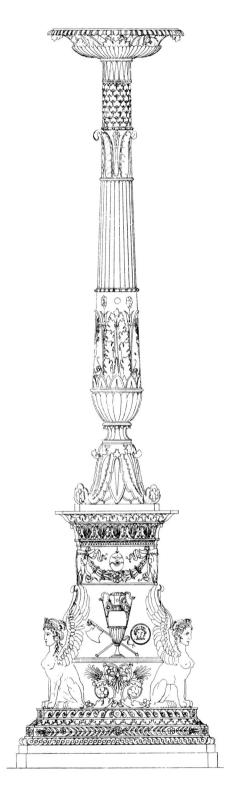

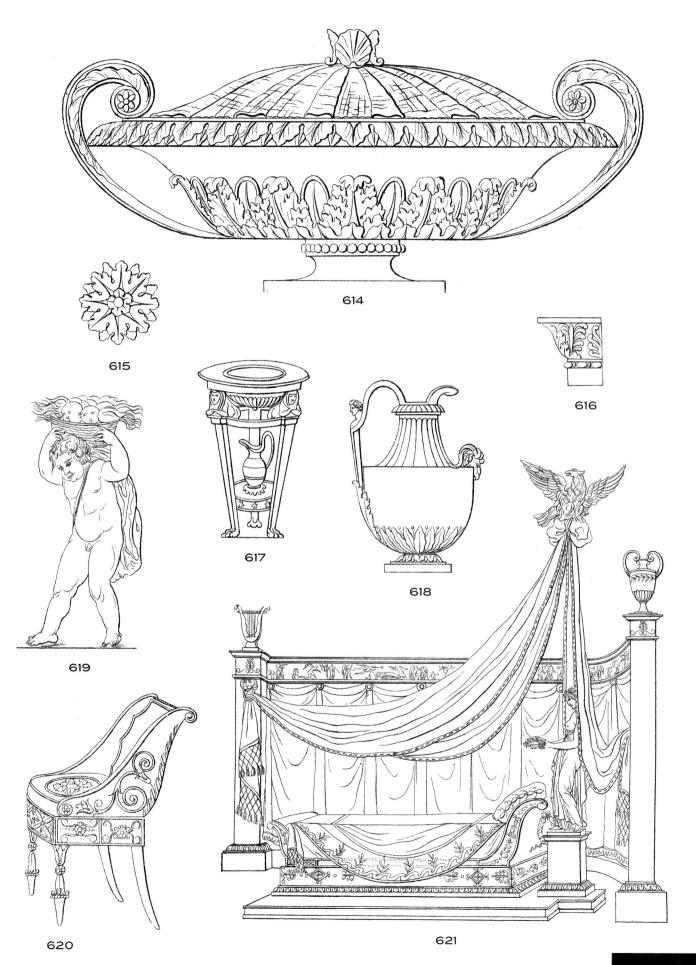

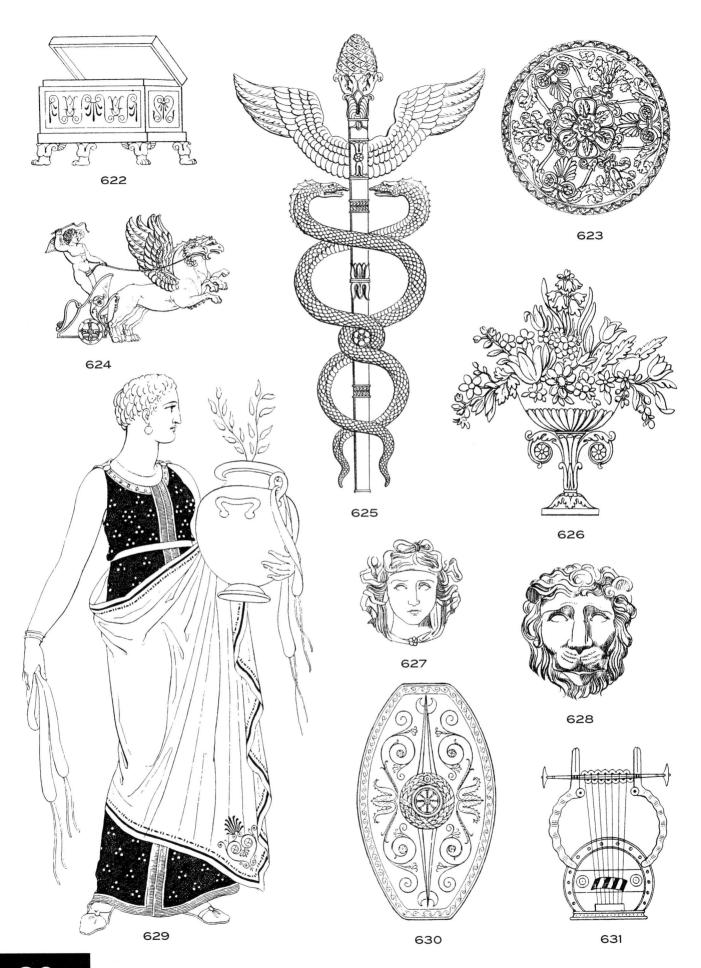

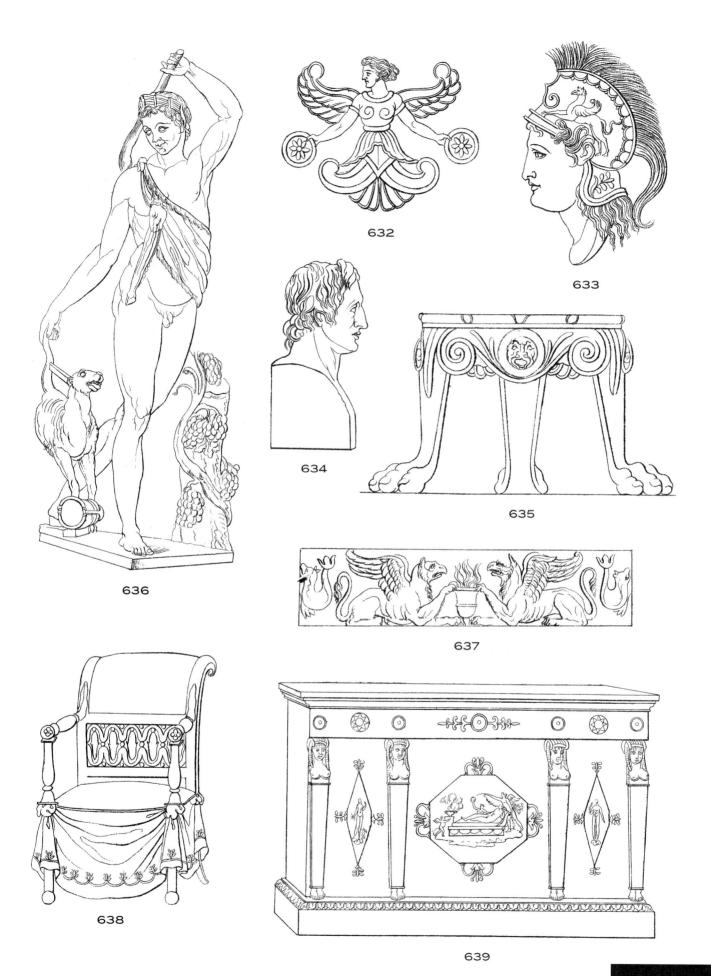

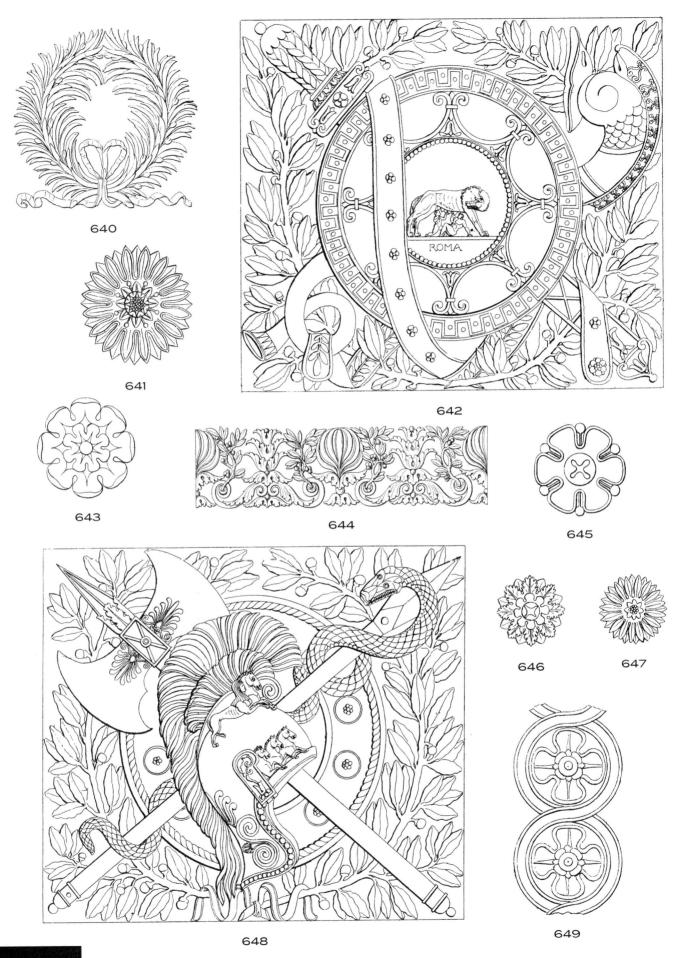

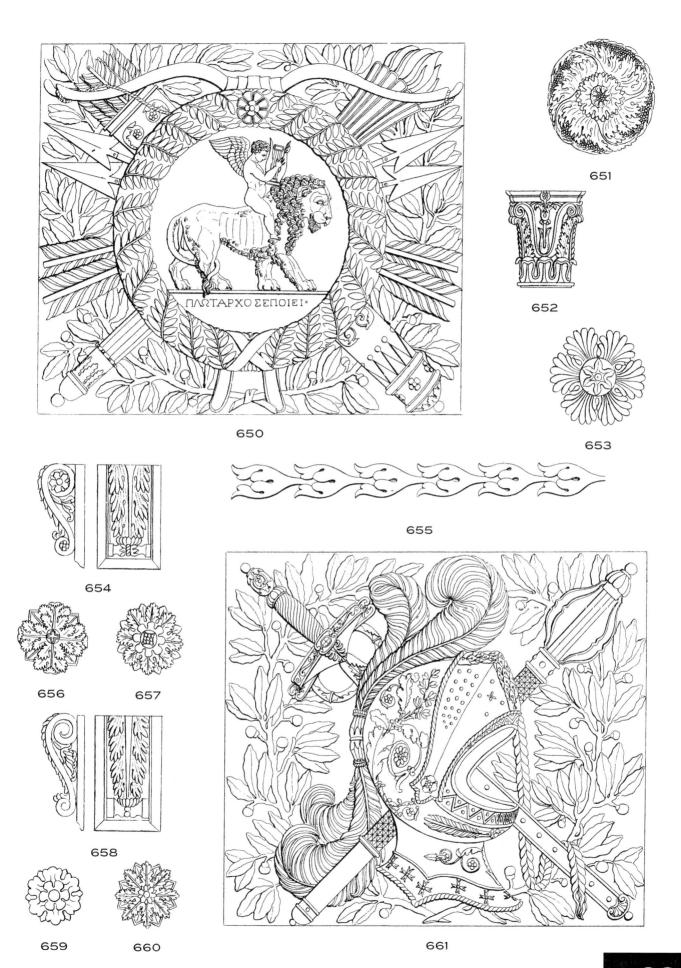

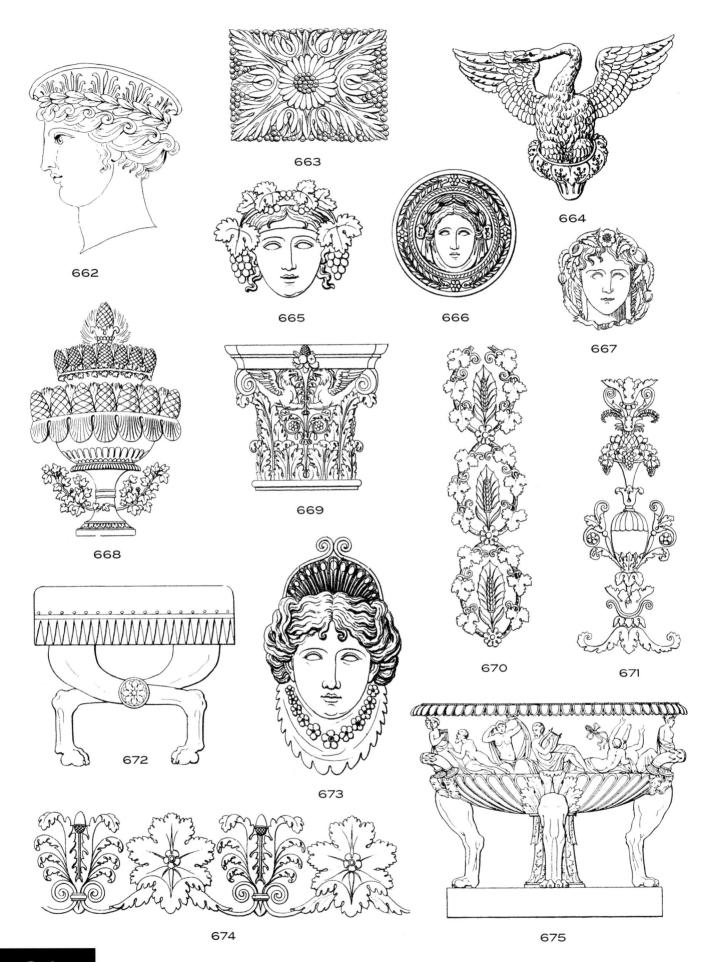

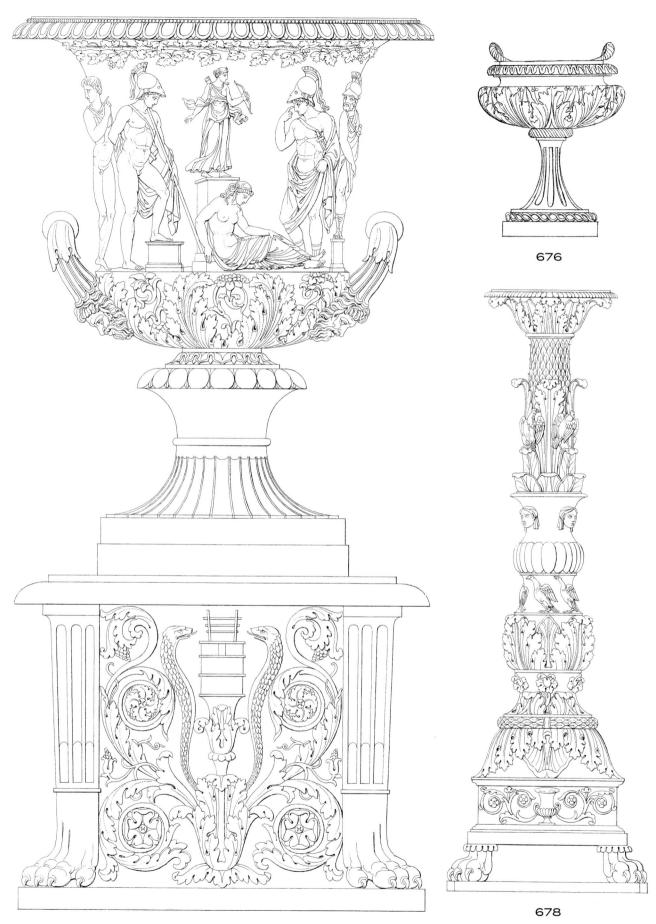

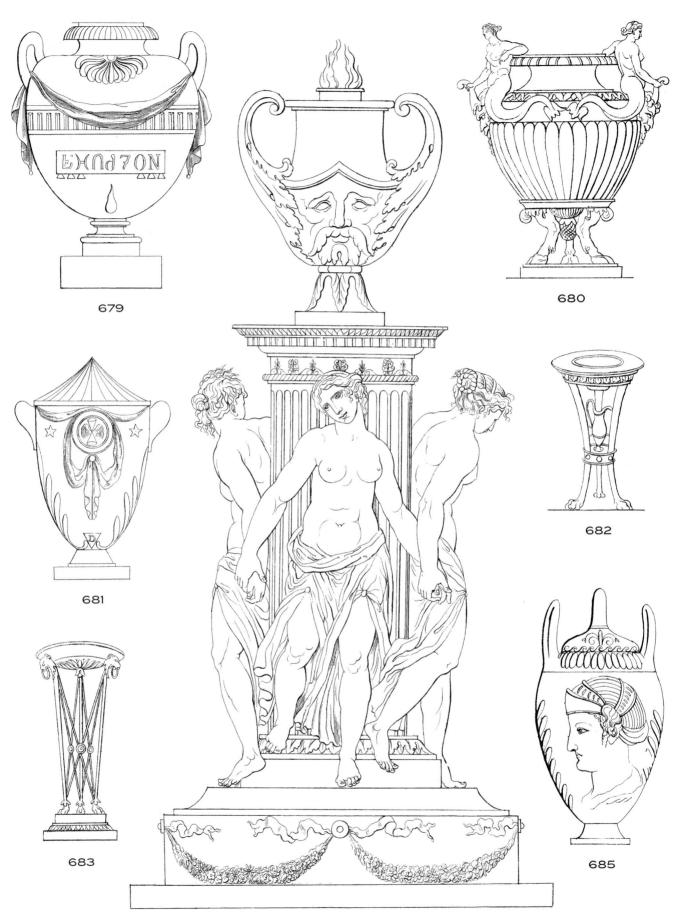

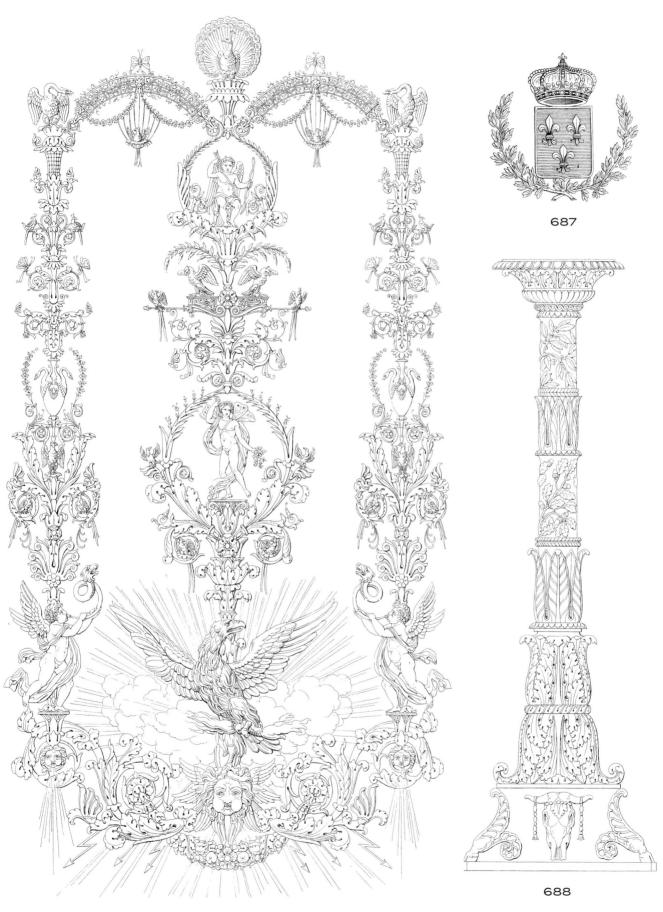

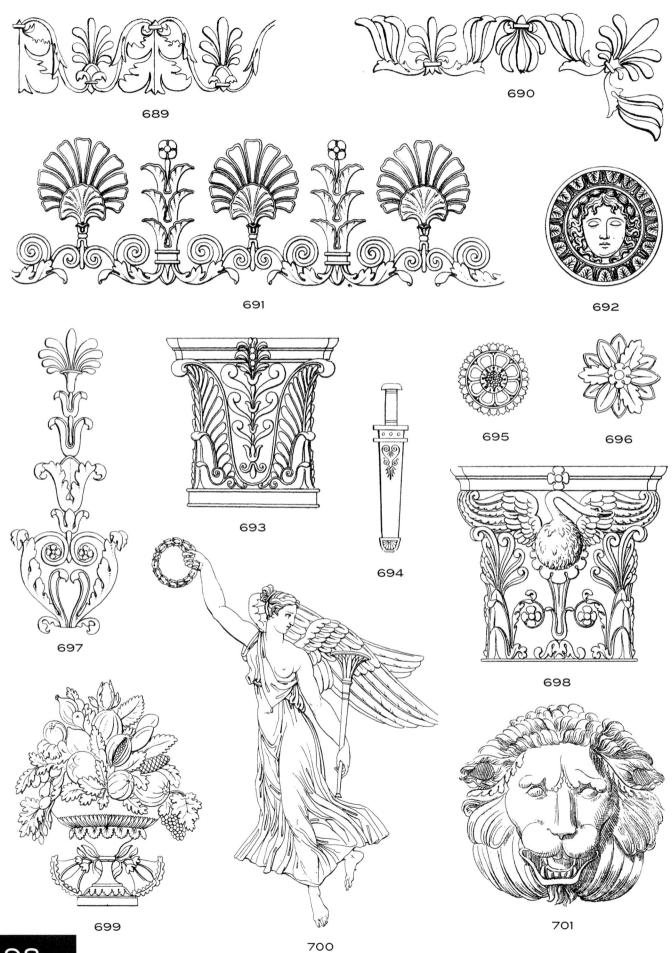

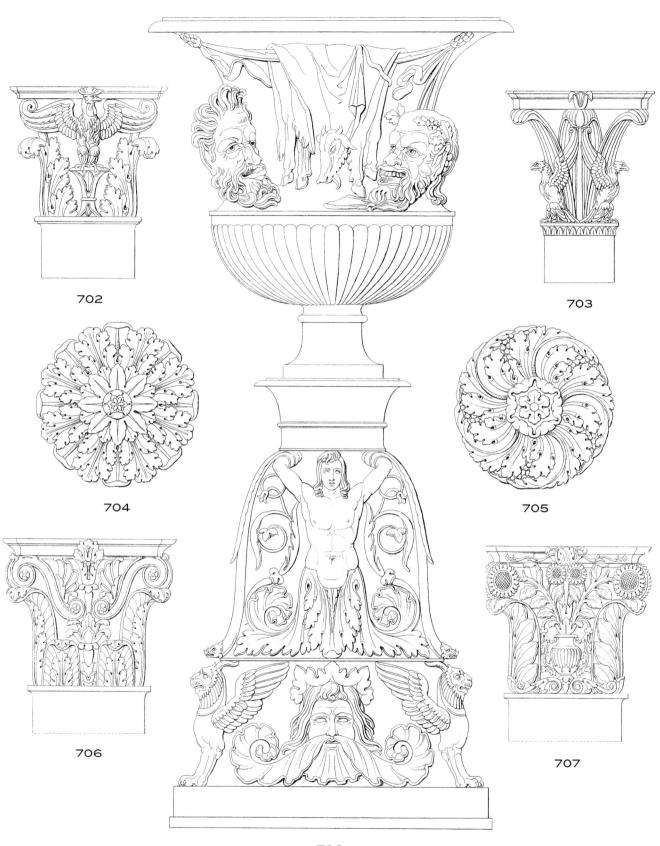

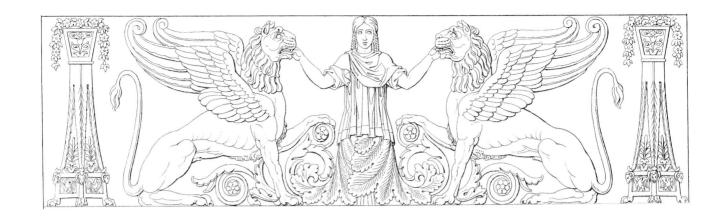

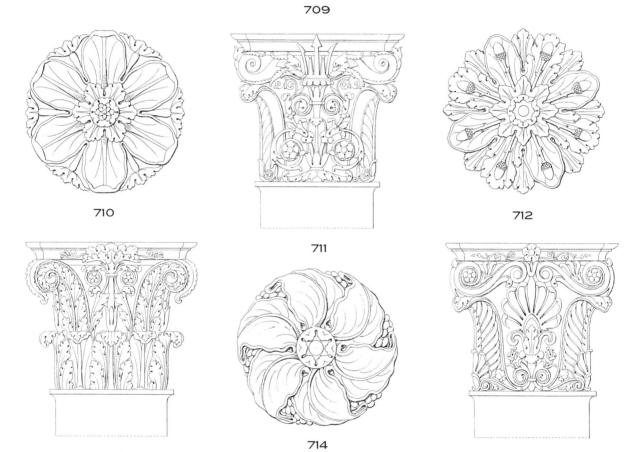

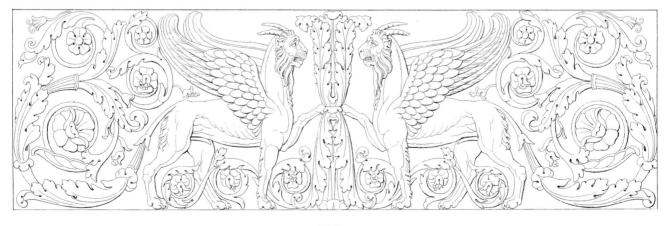

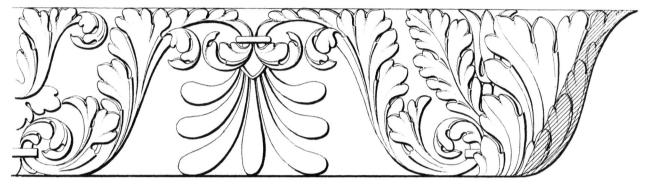

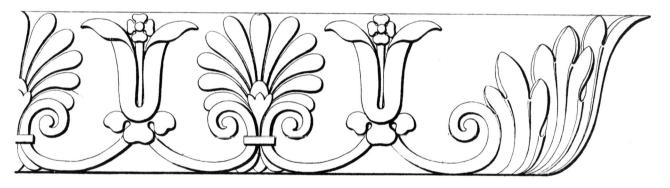

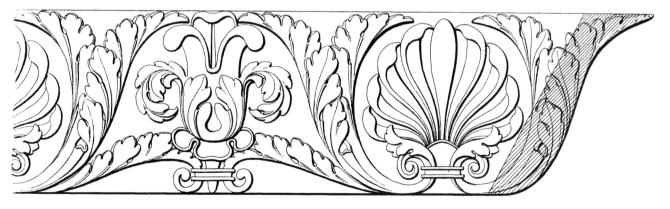

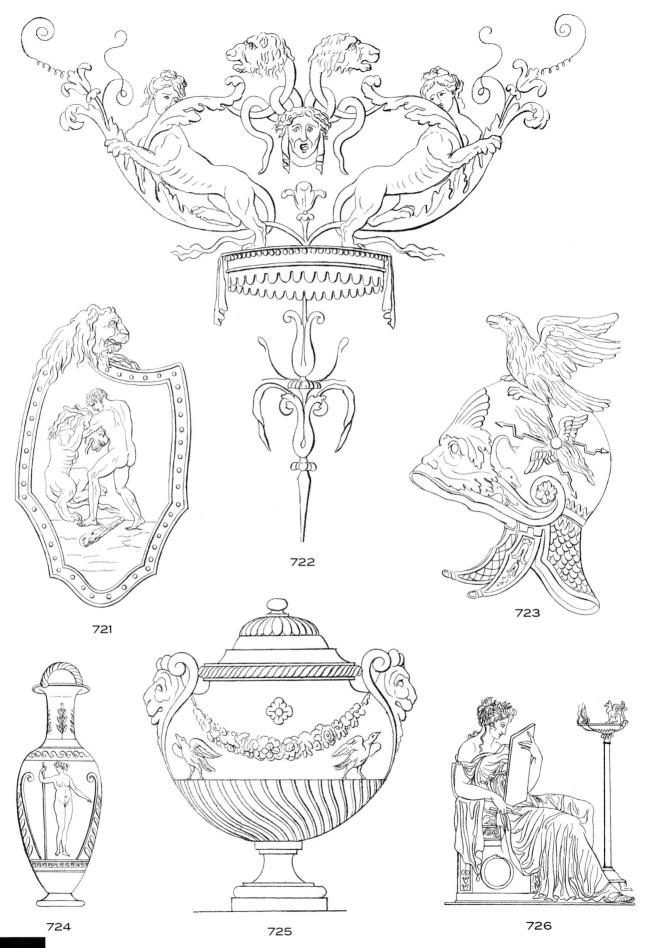

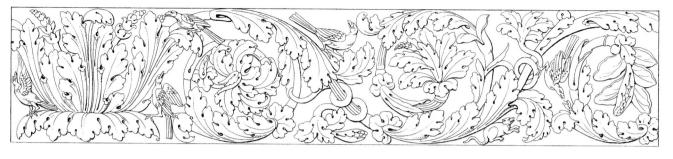

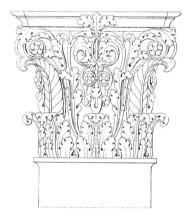

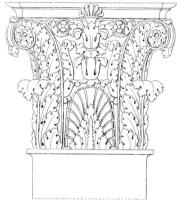

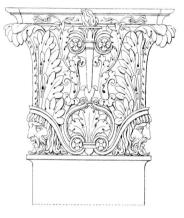

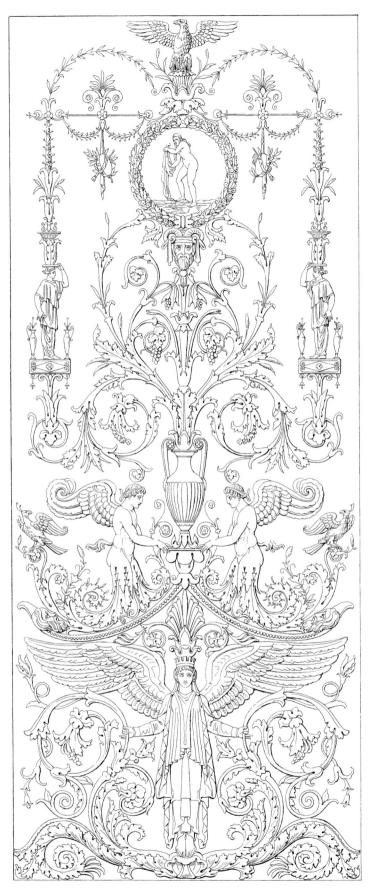

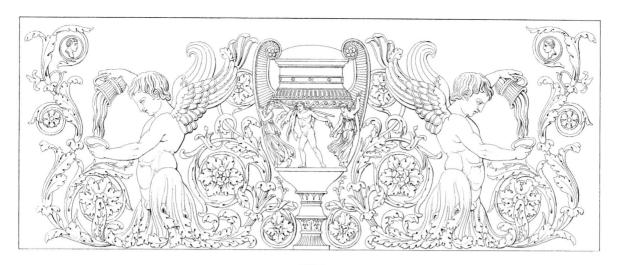

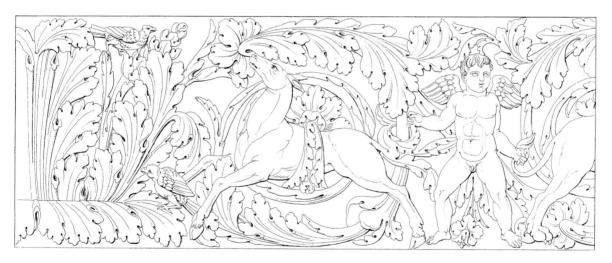

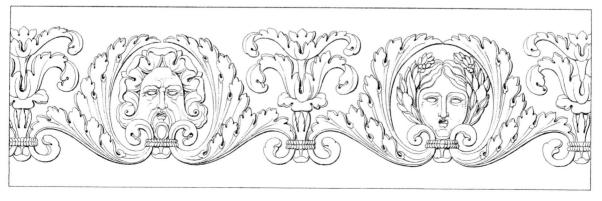

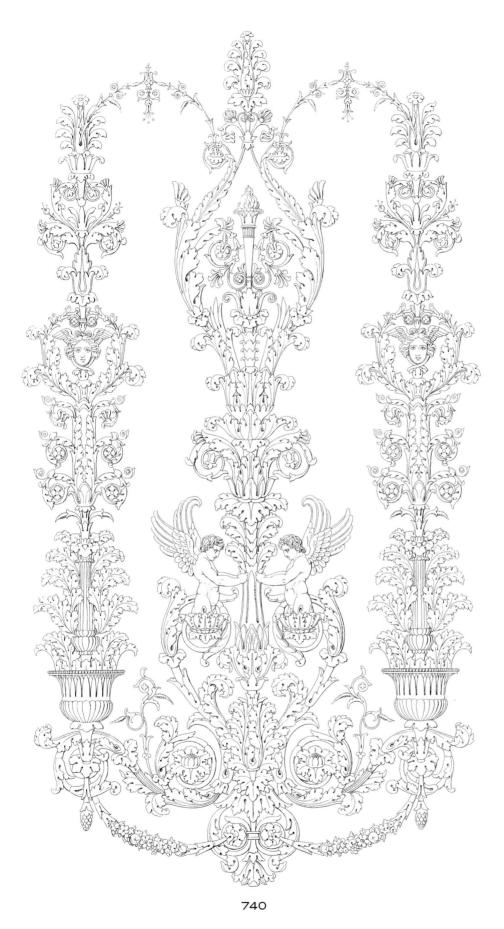

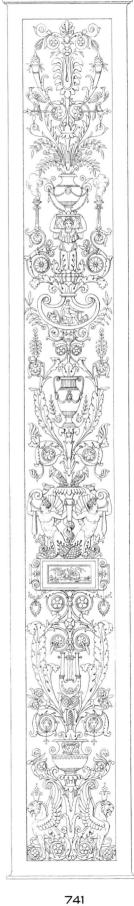

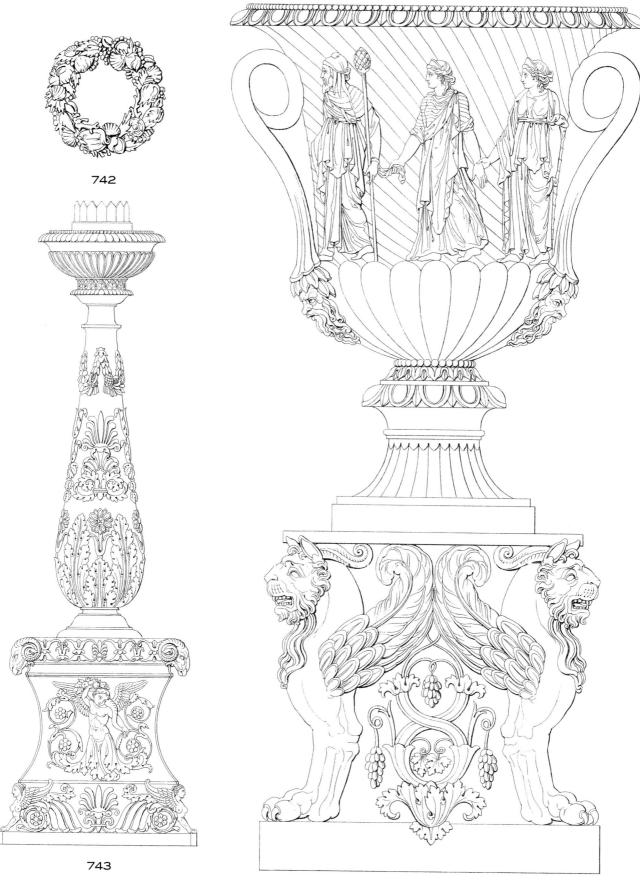

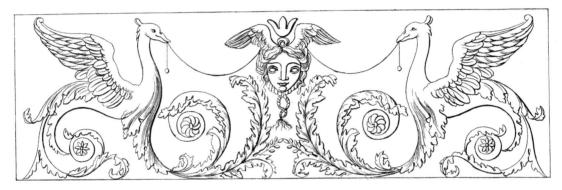

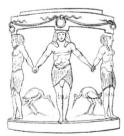

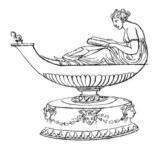

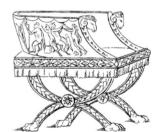

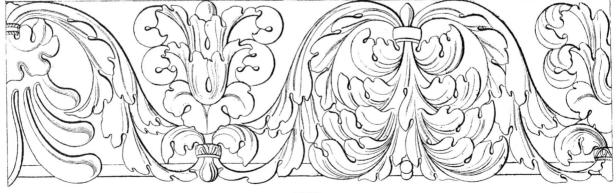

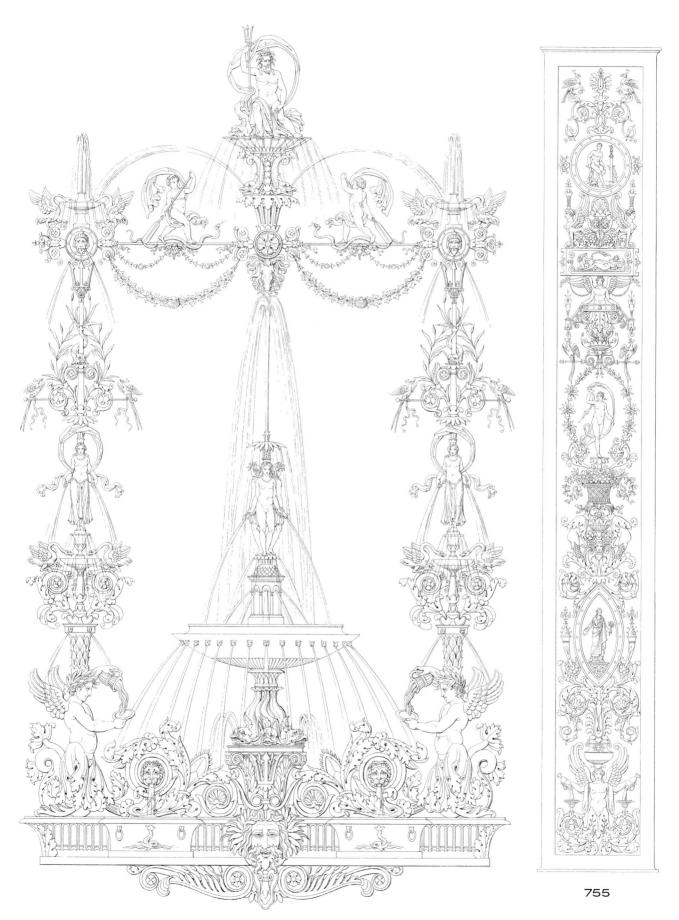

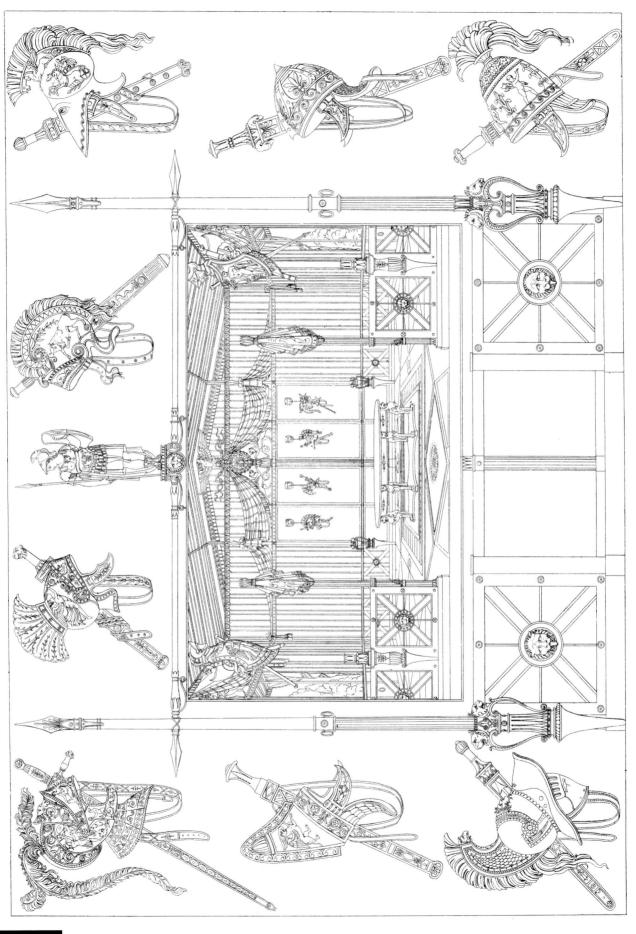

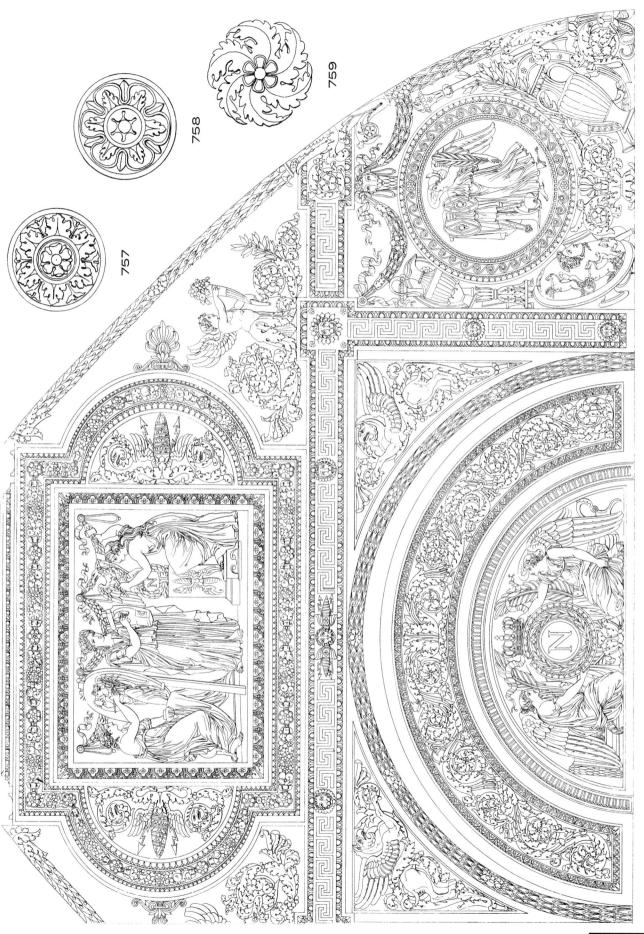

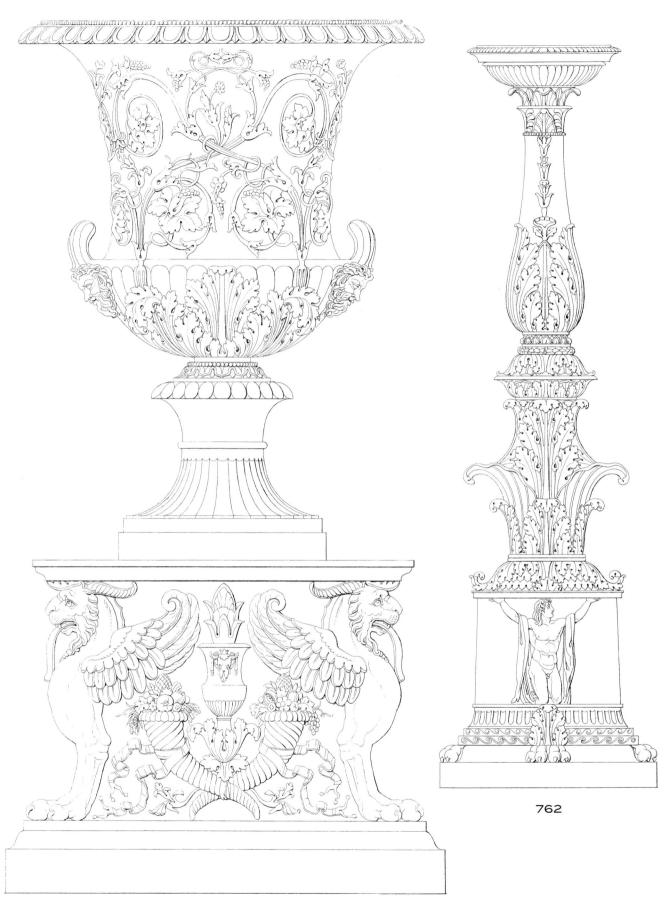

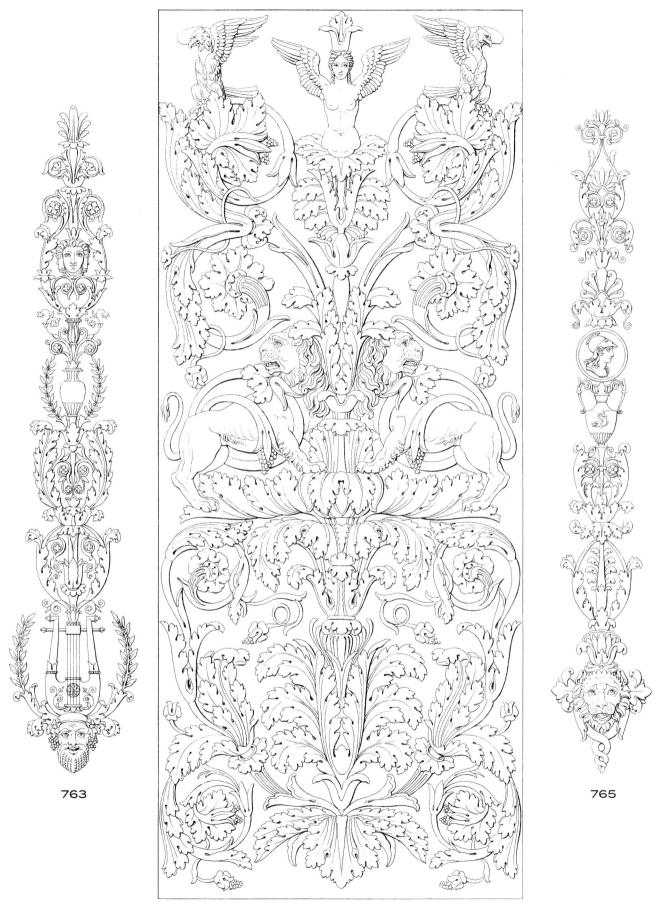

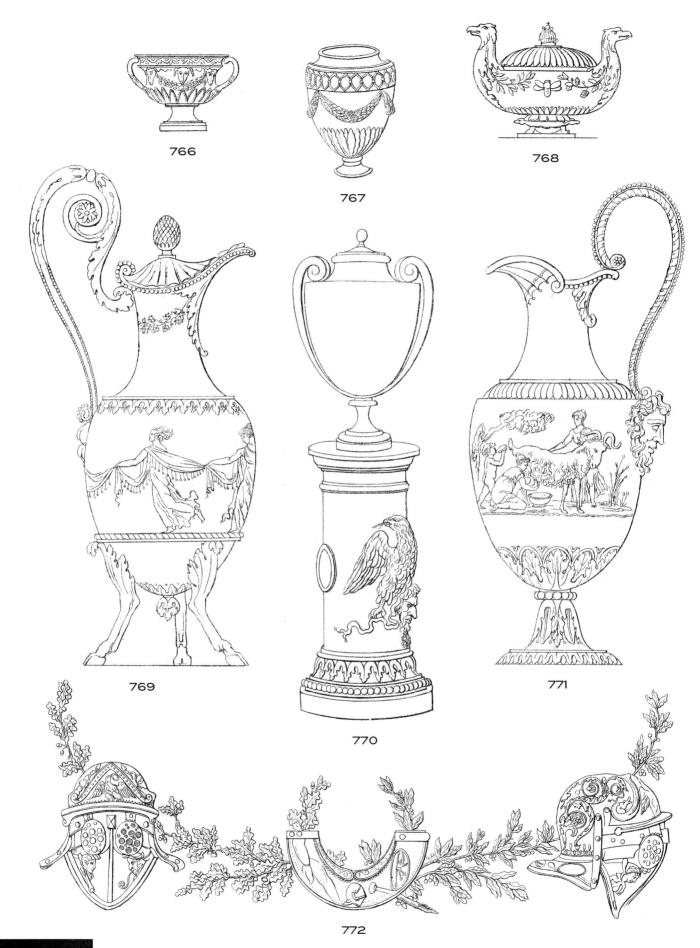

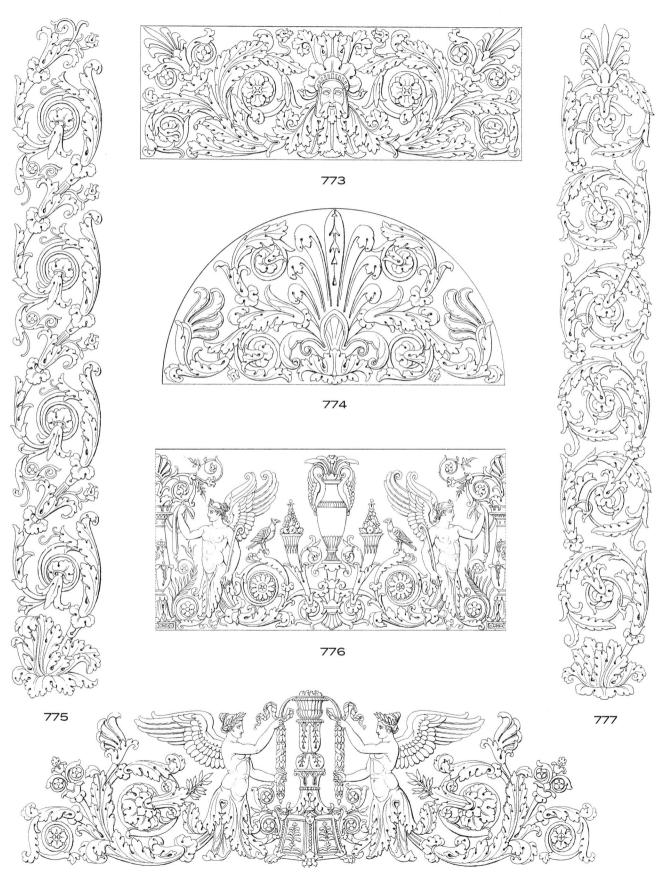

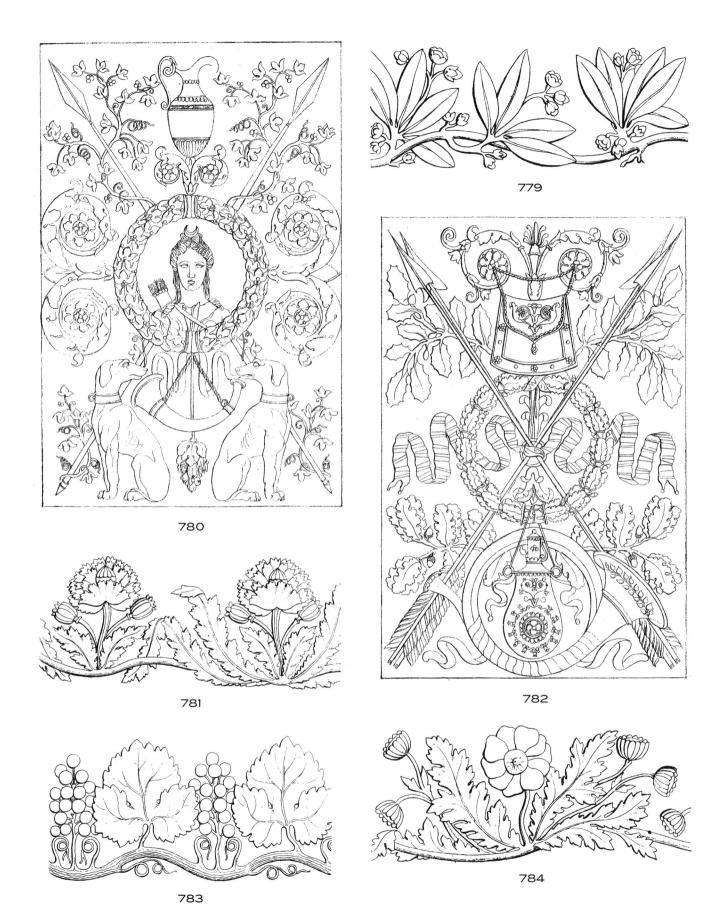

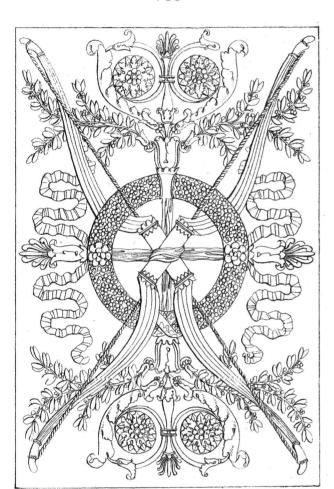

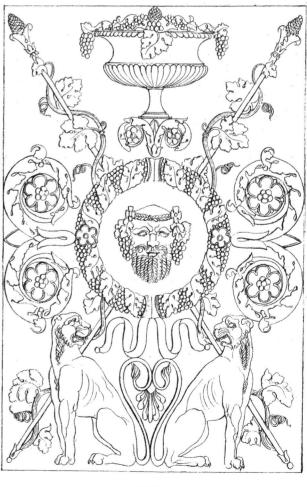

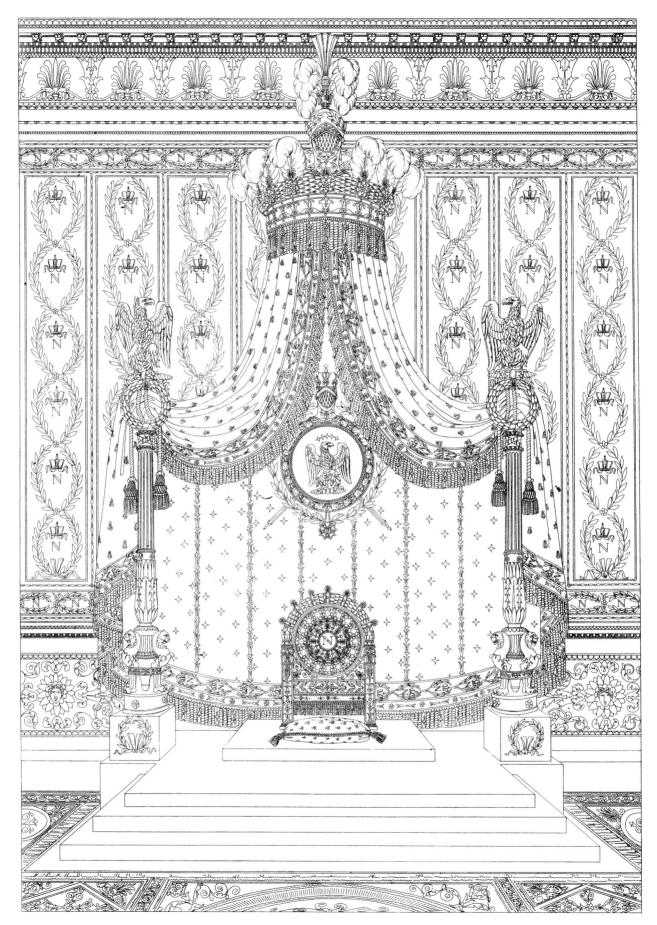

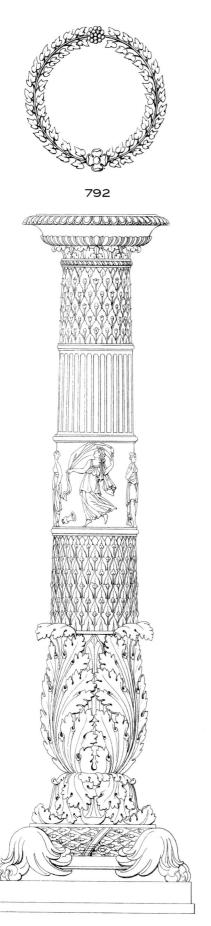

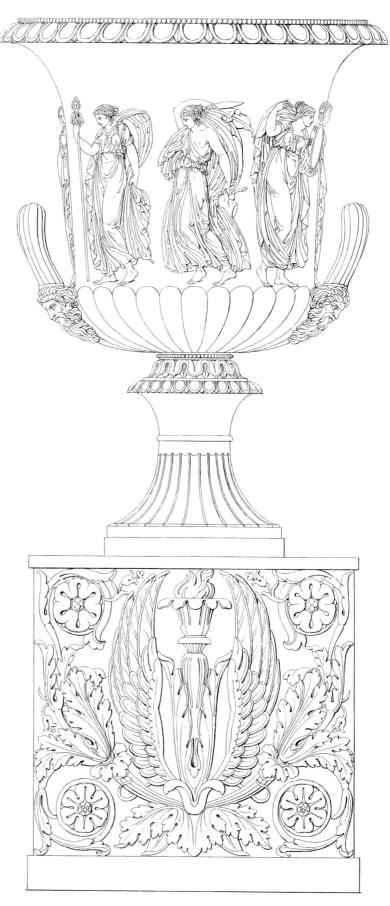

793 794

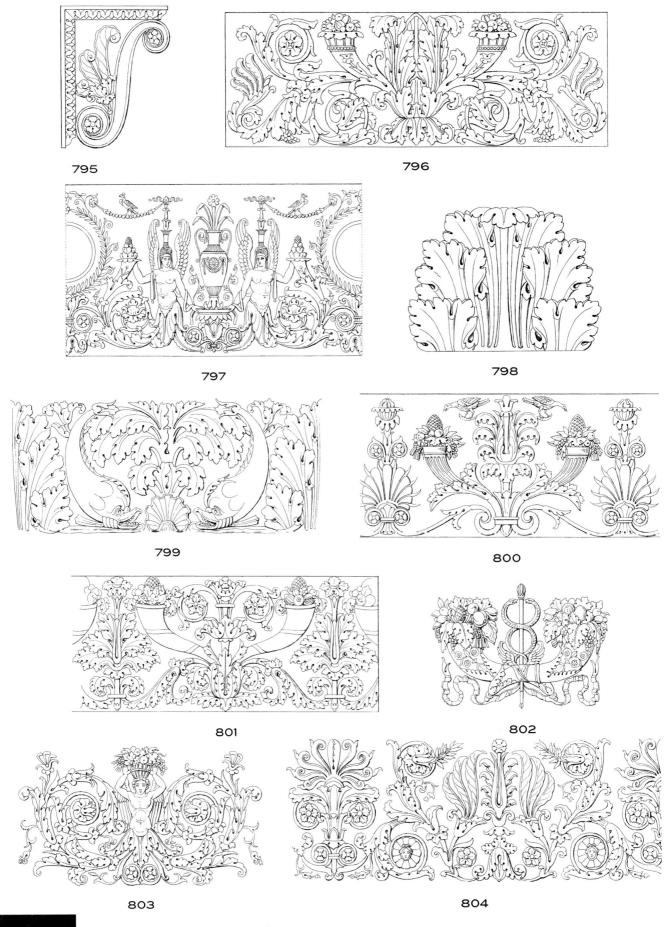

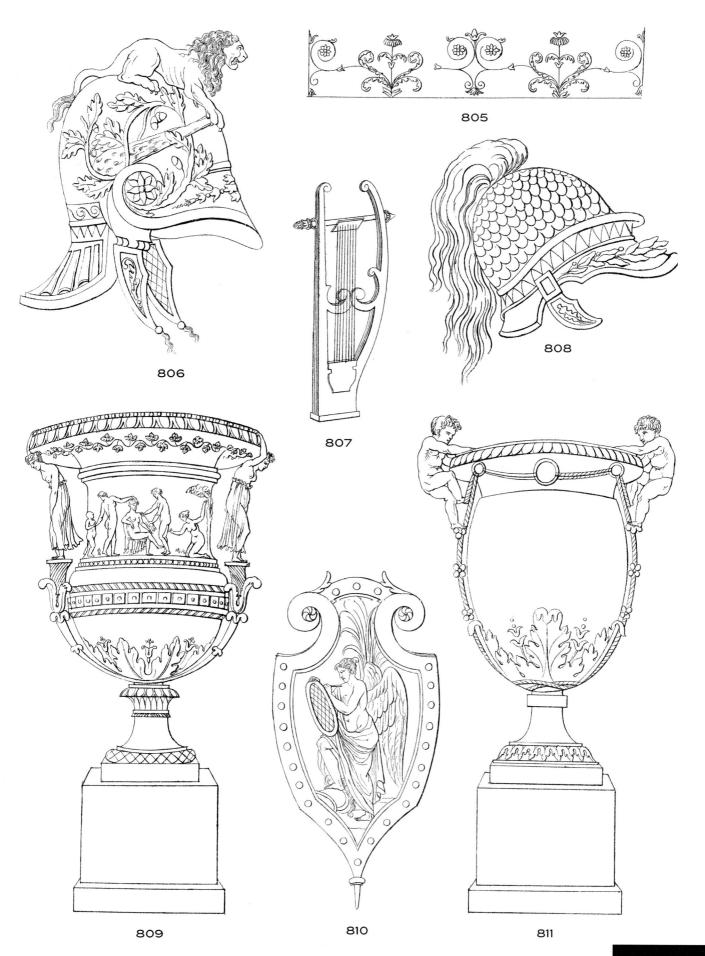

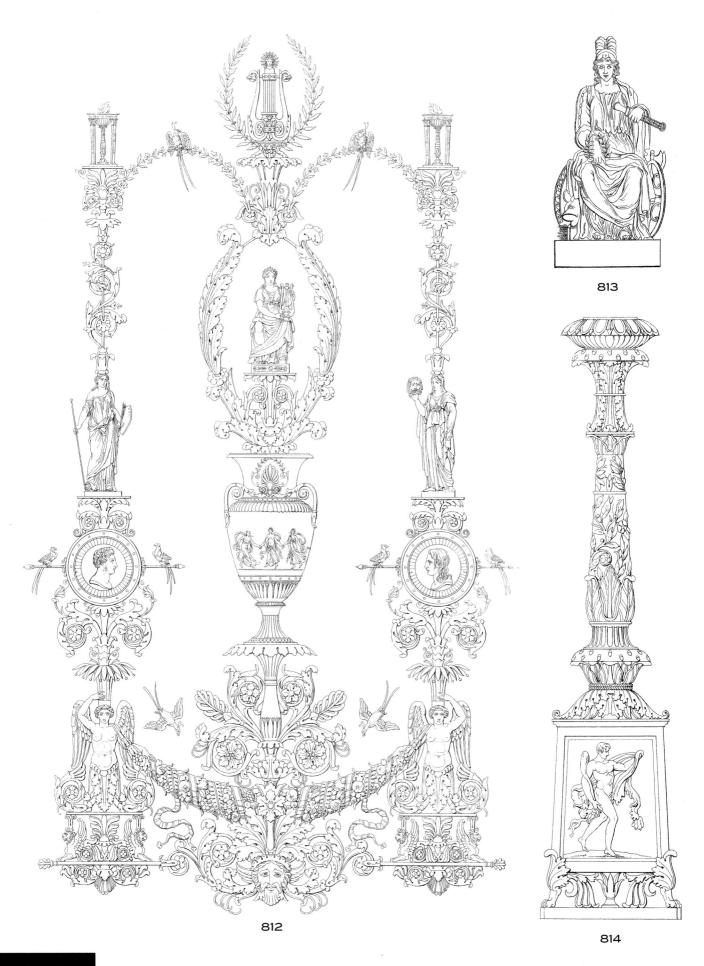

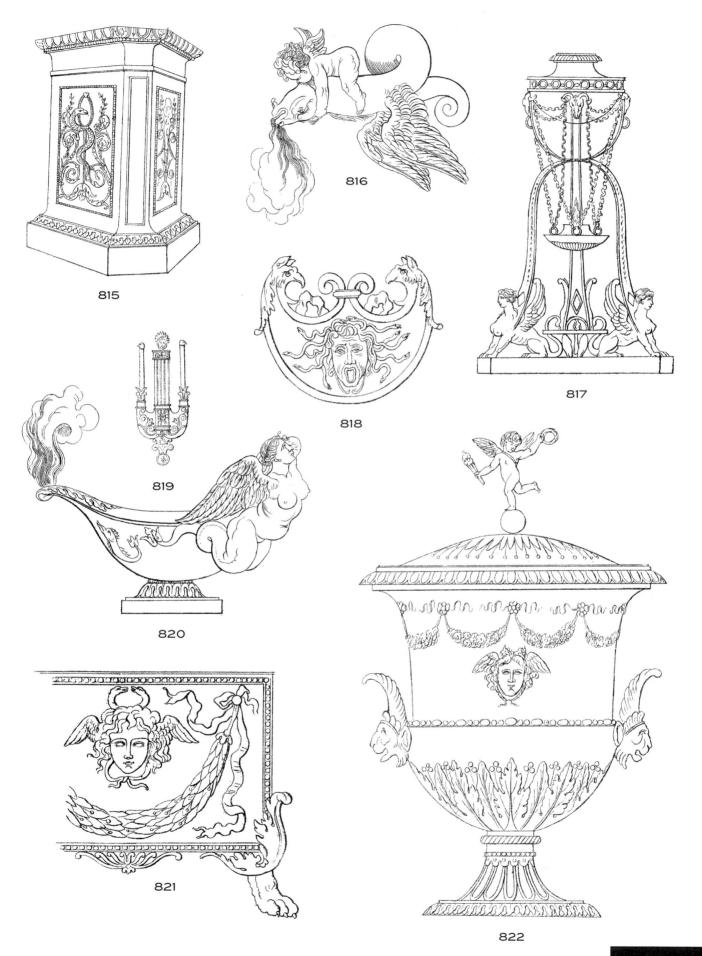

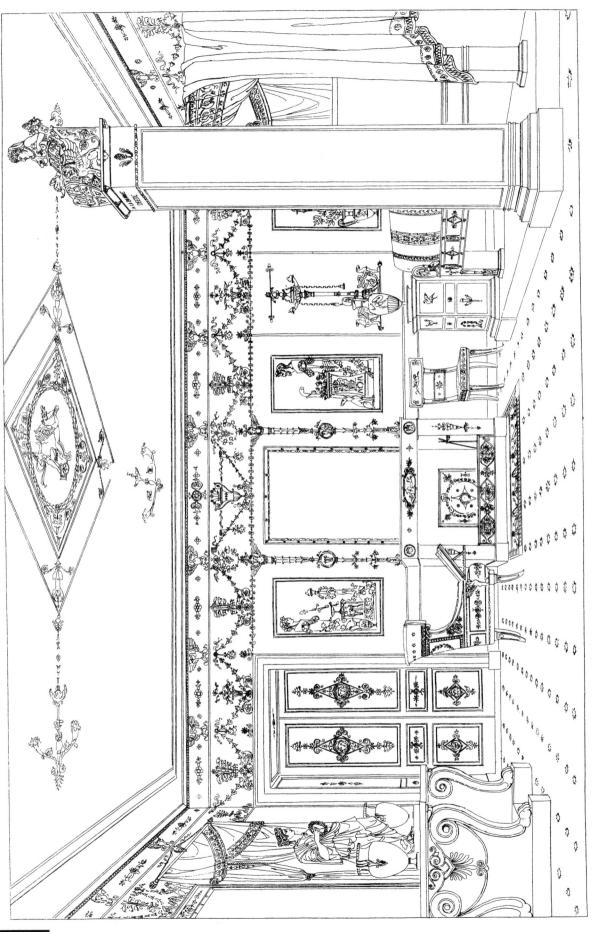